COMPUTER GRAPHICS 2

More of the Best Computer Art and Design

Arambula

FIRST PUBLISHED IN THE UNITED STATES OF AMERICA BY:
ROCKPORT PUBLISHERS, INC. AND ALLWORTH PRESS
146 GRANITE STREET
ROCKPORT, MASSACHUSETTS 01966
TELEPHONE: (508) 546-9590
FAX: (508) 546-7141
TELEX: 5106019284 ROCKORT PUB

DISTRIBUTED TO THE BOOK TRADE AND ART TRADE IN THE U.S. AND CANADA BY:
NORTH LIGHT, AN IMPRINT OF
F & W PUBLICATIONS
1507 DANA AVENUE
CINCINNATI, OHIO 45207
TELEPHONE: (513) 531-2222

OTHER DISTRIBUTION BY:
ROCKPORT PUBLISHERS, INC. ROCKPORT, MASSACHUSETTS 01966

ISBN 1-56496-090-0

10 9 8 7 6 5 4 3 2 1

ART DIRECTOR: LAURA HERRMANN
DESIGNER: CARDINAL INC.
PRODUCTION MANAGER: BARBARA STATES
PRODUCTION ASSISTANT: PAT O'MALEY

PRINTED IN HONG KONG

COMPUTER GRAPHICS 2
More of the Best Computer Art and Design

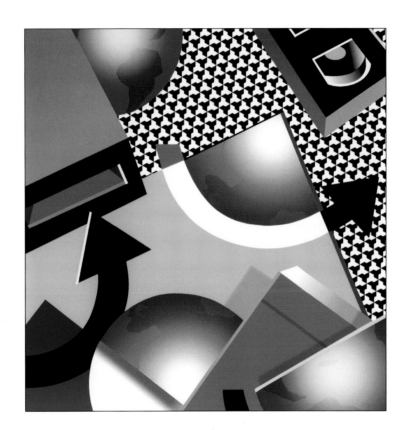

ROCKPORT ALLWORTH EDITIONS
ROCKPORT PUBLISHERS, INC. / ALLWORTH PRESS
DISTRIBUTED BY NORTH LIGHT BOOKS • CINCINNATI, OHIO

CONTENTS

Introduction 7

Graphic Design 9

Illustration & Fine Art 53

Packaging 133

Corporate Identity 145

Broadcast Design 151

Directory 158

Index 160

Visual Redefinition

BY *LIANE SEBASTIAN*

AS MEDIA CHANGE, THE NOTION OF EXPRESSION AND BEING AN ARTIST EVOLVES AHEAD OF IT. THE WORLD IS BECOMING MORE VISUAL. AT THE SAME TIME THAT ITS VALUE MAY BE DECREASING, THE IMPORTANCE OF AN IMAGE IS INCREASING, OR AT LEAST BEING TRANSFORMED. THIS IS BECAUSE MORE PEOPLE HAVE IMAGES AVAILABLE TO THEM THROUGH TECHNOLOGY. TALENT IS STILL ALWAYS A FILTER — AN EDITOR — AND DEFINES QUALITY. BUT THE PLAYING FIELD HAS CHANGED, AND WILL CONTINUE TO CHANGE, SIGNIFICANTLY.

IMAGES ARE EASIER TO CREATE. DESIGNERS WHO COULD NOT DRAW WERE ALWAYS AT A DISADVANTAGE IN THE PAST. TODAY, THE COMPUTER COMPENSATES FOR LACK OF RENDERING SKILLS. IT ALSO MEANS THAT MORE PEOPLE HAVE THESE TOOLS AVAILABLE, SO USERS WITHOUT VISUAL TRAINING ARE ABLE TO CREATE MORE IMAGES.

COMPUTER IMAGING IS FUN AND MAGICAL. DRAWING WITH PENCIL OR PAINTING WITH A BRUSH HAS ALWAYS SEEMED LIKE HARD WORK TO THE AVERAGE PERSON. BUT THE ENGROSSING MEDIUM OF TECHNOLOGY LENDS A ROMANCE AND INTRIGUE TO THOSE SITTING IN FRONT OF THE SCREEN. THE GRAPHIC ARTS HAVE BECOME MORE COMPELLING TO A LARGER NUMBER OF PEOPLE — THE INFLUX INTO THE PROFESSION OF NEW PROFESSIONALS AND CAREER-SHIFTERS HAS NEVER BEEN GREATER.

IMAGES ARE EASIER TO COPY. WITH THE SOPHISTICATION OF SCANNERS AND IMAGE MANIPULATION SOFTWARE, ANYONE WITH RATHER INEXPENSIVE EQUIPMENT CAN INPUT JUST ABOUT ANY IMAGE THEY CAN FIND. THE KNOWLEDGE OF COPYRIGHT AND ETHICS LAGS SADLY BEHIND THE REALITY OF CAPABILITIES. MOST USERS ARE VERY INNOCENT ABOUT THEIR "BORROWING." THEY DON'T MEAN TO DO SOMETHING HARMFUL TO CREATIVITY. BECAUSE TECHNOLOGY MAKES COPYING EASY, THEY FIGURE IT IS OKAY TO DO MICH LIKE COPYING A MUSICAL CD AND GIVING IT TO FRIENDS.

STOCK IMAGES ARE POPPING UP LIKE DANDELIONS IN A FIELD, AND THE PRICE PER VISUAL IS DROPPING. CDS THAT CONTAIN HUNDREDS OF IMAGES ARE BEING SOLD FOR LESS THAN $100. MANY OF THESE ARE HIGH-QUALITY SPOT ILLUSTRATIONS, TEXTURES, BORDERS, AND ICONS. WITH THE RIGHT CONNECTIONS, THE GRAPHIC ARTIST'S MAILBOX IS FILLED WITH OFFERINGS OF NEW STOCK PHOTOS AND ILLUSTRATIONS.

IMAGE DATABASES WILL BECOME BIG BUSINESSES AND WILL PROLIFERATE THE STOCK AVAILABILITY. THE GRAPHIC ARTIST WILL HAVE THEIR OWN IMAGE LIBRARIES, BOTH FROM STOCK AND FROM THEIR OWN CREATION. MANAGING THESE IMAGES WILL REQUIRE SPECIAL SOFTWARE KNOWLEDGE AND CATALOGING.

STORAGE AND RETRIEVAL WILL BECOME CRITICAL AND WILL STEM FROM AN OVERSTUFFED ELECTRONIC FILE CABINET. ARTISTS AREN'T KNOWN FOR THEIR ORGANIZATION. MOST STUDIOS ARE TORRENTS OF PAPER, TOOLS, AND SOURCE MATERIALS FLYING AROUND. NOW THEY WILL FLY AROUND IN BITS AND BYTES, MYSTERIOUSLY HIDDEN IN DIGITAL CONFUSION. THE MORE ORGANIZED THE ARTIST, THE MORE IMAGES BECOME LANGUAGE.

IN THE PAST, THE ARTIST'S PALETTE HAD DABS OF COLOR THAT HIS OR HER BRUSH WOULD DIP INTO FOR THE DESIRED HUE. TODAY, THAT PALETTE HAS BECOME THE WORLD OF IMAGES. WHOEVER CAN COMMAND THESE IMAGES AND SKILLFULLY USE THEM TO COMMUNICATE IMPORTANT MEANING AND CONTENT WILL BE THE ARTISTS OF THE FUTURE. THOUGH TALENT HAS ALWAYS SEPARATED THE PROFESSIONAL FROM THE AMATEUR, THE EXCELLENT FROM THE MEDIOCRE, THE VIRTUOSOS FROM THE NOVICE, VISUAL EXPRESSION MUST ALSO FIND A VISUALLY LITERATE AUDIENCE. CLARITY OF CONTENT AND PURPOSE WILL CONTINUE TO SHINE THROUGH THE MORASS OF VISUAL PROLIFERATION HOPEFULLY, AS PEOPLE SEE MORE, THEY WILL BECOME MORE SENSITIVE AND KNOWLEDGEABLE OF VISUAL LANGUAGE. THE EVOLUTION OF RECOGNITION, THOUGH, BEGINS WITH THE THOUGHTFUL, SKILLFUL, AND TALENTED ARTIST. THIS IS SOMETHING THAT WILL NEVER CHANGE.

Graphic Design

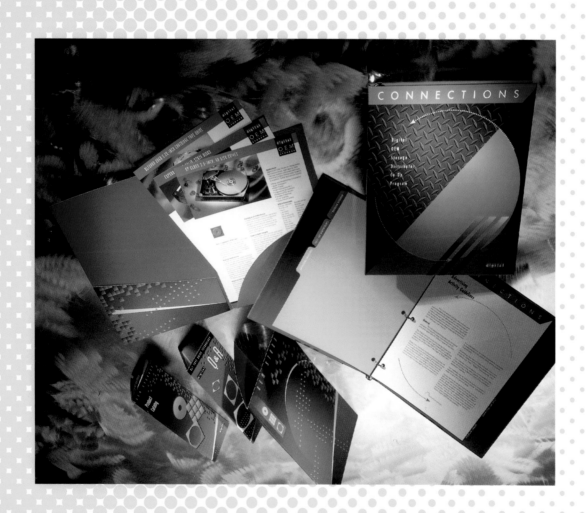

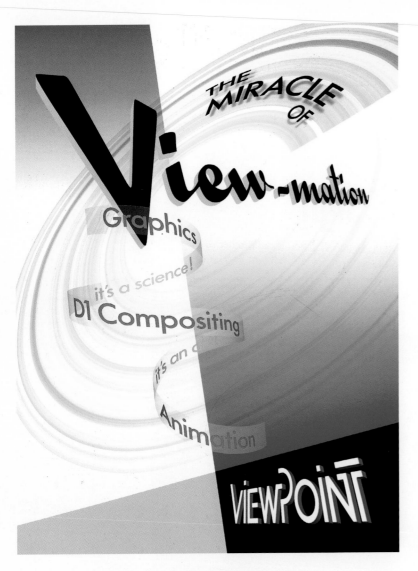

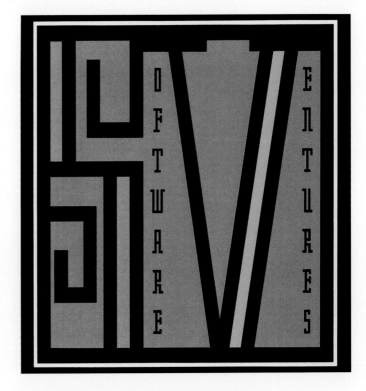

DESIGN FIRM VIEWPOINT COMPUTER ANIMATION
ART DIRECTOR MATT HAUSMAN, BRIAN BRAM
DESIGNER MATT HAUSMAN, BRIAN BRAM
SOFTWARE PRISMS
HARDWARE SILICON GRAPHICS WORKSTATIONS

DESIGN FIRM MIKE SALISBURY COMMUNICATIONS INC.
ART DIRECTOR MIKE SALISBURY
DESIGNER REGINA GROSVELD
CLIENT SOFTWARE VENTURES
SOFTWARE ADOBE ILLUSTRATOR
HARDWARE MAC IICX

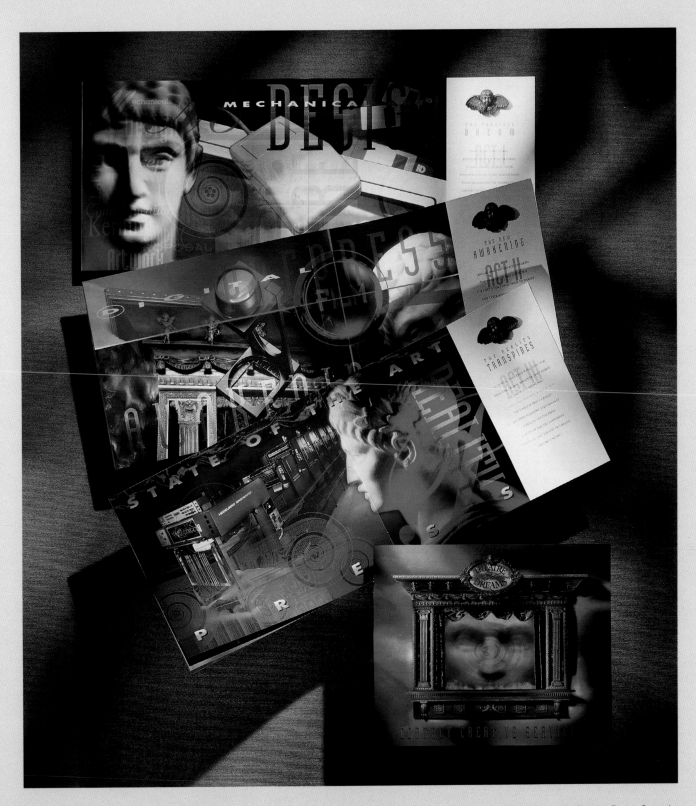

DESIGN FIRM	THE RIORDON DESIGN GROUP INC.
ART DIRECTOR	RIC RIORDON
DESIGNER	RIC RIORDON, DAN WHEATON
CLIENT	CONTACT CREATIVE SERVICES INC.
SOFTWARE	ADOBE PHOTOSHOP, QUARKXPRESS, RAY DREAM DESIGNER
HARDWARE	MAC QUADRA 950

MODELS WERE BUILT AND MARRIED WITH OTHER PHOTOGRAPHY.

DESIGN FIRM P.I. DESIGN CONSULTANTS
ART DIRECTOR DON WILLIAMS
DESIGNER DON WILLIAMS, RICHARD EVANS
CLIENT HEINZ (UK)
SOFTWARE ALDUS FREEHAND
HARDWARE MAC IIFX

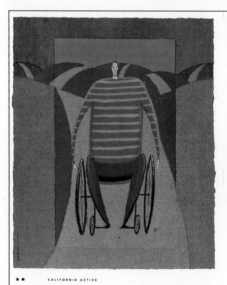

AS TOLD BY ALBERT CRUZ

A
Tale BEATING
of THE
ODDS
Overcoming

On October 1, 1990, as I walked over to a friend's car on Gregory Street in Hollywood, I had no idea that it was the last time I would walk normally.

I didn't hear the AK47, nor did I feel the armor-piercing bullet shatter my spinal column. The force of the bullet threw me at least eight feet before dropping me to the pavement. I lost consciousness for a moment, but as soon as I was aware that I was the victim of a drive-by shooting, I saw a second bullet tear through my leg. All the while I tried to get up, not realizing I was paralyzed from the waist down. Nor did I know that my friend Ernie had been shot twice in the head and was lying dead just a few feet from me.

ILLUSTRATION BY DAN YACCARINO

CALIFORNIA ACTIVE CALIFORNIA ACTIVE

DESIGN FIRM MIKE SALISBURY COMMUNICATIONS INC.
ART DIRECTOR MIKE SALISBURY
DESIGNER REGINA GROSVELD
CLIENT CALIFORNIA ACTIVE
SOFTWARE QUARKXPRESS
HARDWARE MAC IICX

DESIGN FIRM SEGURA INC.
ART DIRECTOR CARLOS SEGURA
DESIGNER CARLOS SEGURA
CLIENT HECK PHOTOGRAPHY
SOFTWARE ADOBE PHOTOSHOP, QUARKXPRESS, ADOBE ILLUSTRATOR,
 ADOBE STREAMLINE, ALTSYS FONTOGRAPHER
HARDWARE MAC QUADRA 800

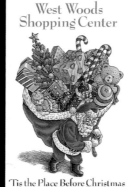

DESIGN FIRM ASLAN GRAFIX
ART DIRECTOR TRACY GRUBBS
DESIGNER TRACY GRUBBS
CLIENT WEST WOODS TENANT ASSOC.
SOFTWARE ADOBE PHOTOSHOP,
 ADOBE ILLUSTRATOR, QUARKXPRESS
HARDWARE MAC QUADRA 700

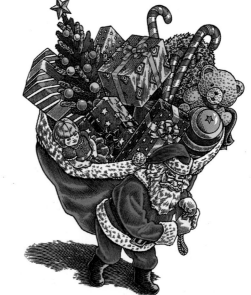

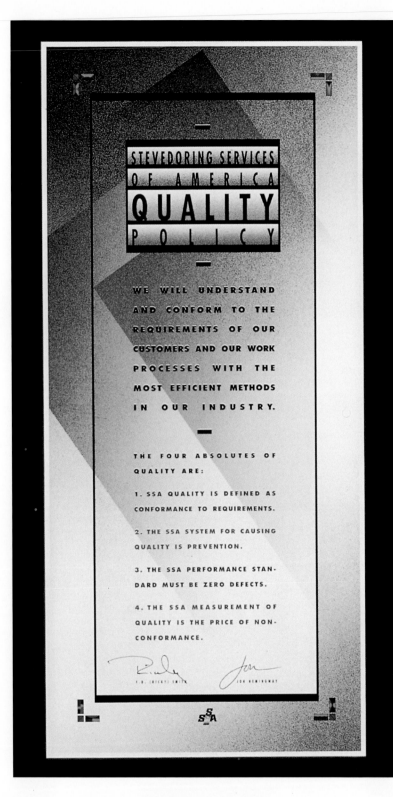

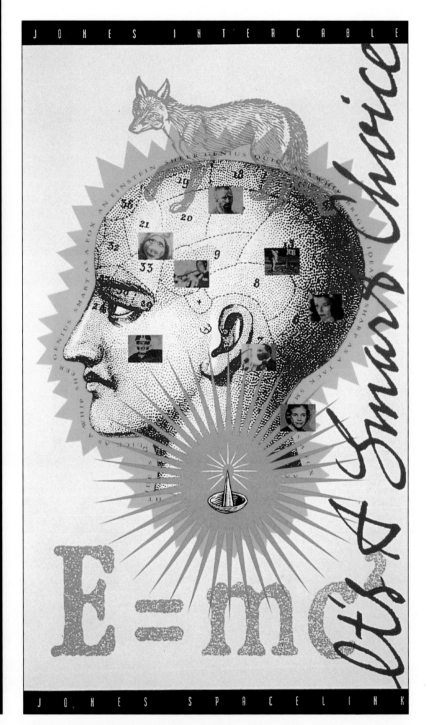

DESIGN FIRM HORNALL ANDERSON DESIGN WORKS
ART DIRECTOR JACK ANDERSON
DESIGNER JACK ANDERSON, PAULA COX, DENISE WEIR, LIAN NG
CLIENT STEVEDORING SERVICES OF AMERICA
SOFTWARE ALDUS PAGEMAKER, ALDUS FREEHAND
HARDWARE MAC QUADRA 800, SUPER MAC THUNDAR II LIGHT

DESIGN FIRM VAUGHN WEDEEN CREATIVE
ART DIRECTOR STEVE WEDEEN, DANIEL MICHAEL FLYNN
DESIGNER DANIEL MICHAEL FLYNN
COMPUTER PRODUCTION CHIP WYLY
CLIENT JONES INTERCABLE
SOFTWARE ALDUS FREEHAND, ADOBE PHOTOSHOP
HARDWARE MAC IICX WITH RADIUS ROCKET

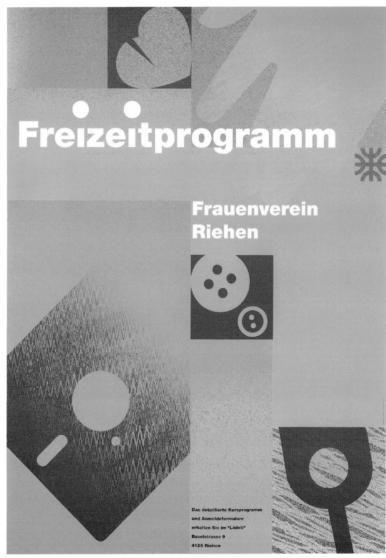

DESIGN FIRM	MIKE SALISBURY COMMUNICATIONS INC.
ART DIRECTOR	MIKE SALISBURY, TOM MARTIN
DESIGNER	MIKE SALISBURY, REGINA GROSVELD
CLIENT	UNIVERSAL PICTURES
SOFTWARE	ADOBE ILLUSTRATOR, QUARKXPRESS
HARDWARE	MAC IICX

DESIGN FIRM	A. RENNER DESIGN
ART DIRECTOR	MICHAEL RENNER
DESIGNER	MICHAEL RENNER
CLIENT	WOMEN'S ORGANIZATION OF RIEHEN, SWITZERLAND
SOFTWARE	ADOBE ILLUSTRATOR, ADOBE PHOTOSHOP
HARDWARE	MAC II

DESIGN FIRM VAUGHN WEDEEN CREATIVE
ART DIRECTOR RICK VAUGHN
DESIGNER RICK VAUGHN
COMPUTER PRODUCTION CHIP WYLY
CLIENT U.S. WEST COMMUNICATIONS
SOFTWARE ADOBE PHOTOSHOP, ALDUS FREEHAND
HARDWARE MAC IICX WITH RADIUS ROCKET

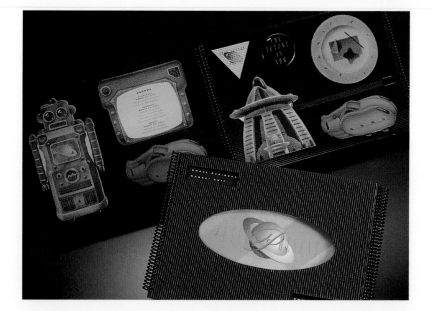

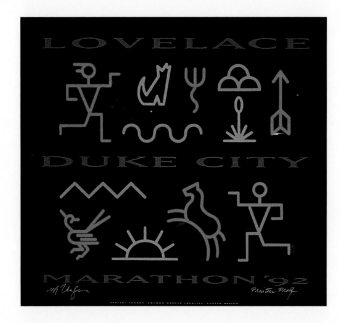

DESIGN FIRM VAUGHN WEDEEN CREATIVE
ART DIRECTOR RICK VAUGHN
DESIGNER RICK VAUGHN
COMPUTER PRODUCTION NANCI EASTER
CLIENT DUKE CITY MARATHON
SOFTWARE ADOBE ILLUSTRATOR
HARDWARE MAC IICX

DESIGN FIRM VAUGHN WEDEEN CREATIVE
ART DIRECTOR STEVE WEDEEN
DESIGNER STEVE WEDEEN
COMPUTER PRODUCTION CHIP WYLY
CLIENT U.S. WEST COMMUNICATIONS
SOFTWARE ADOBE PHOTOSHOP, ALDUS FREEHAND, QUARKXPRESS
HARDWARE MAC IICX WITH RADIUS ROCKET

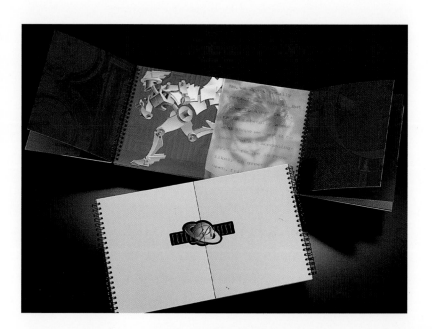

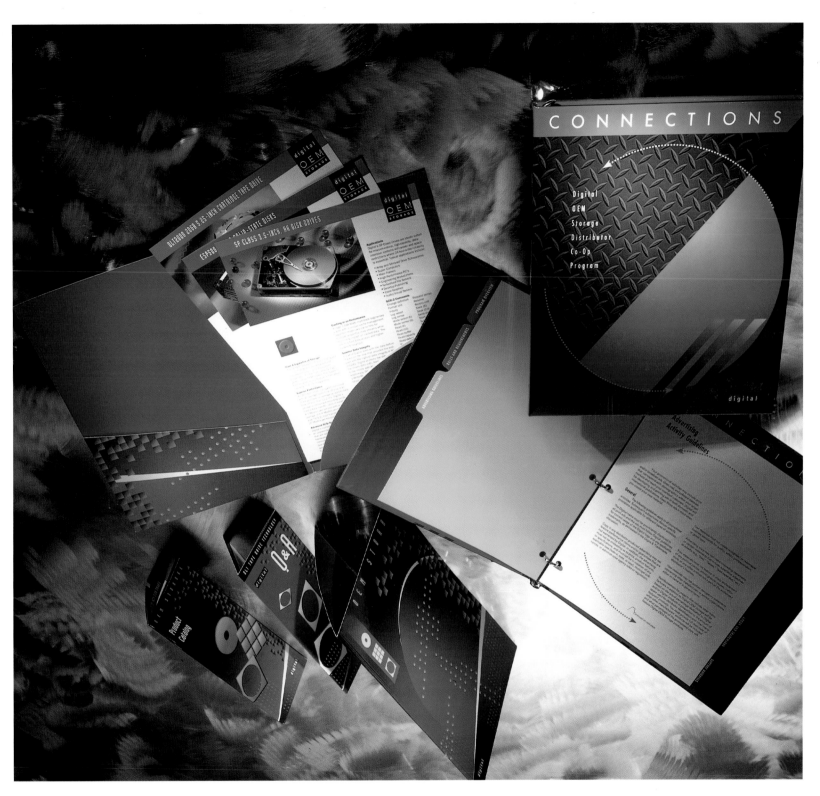

DESIGN FIRM	LARSEN DESIGN OFFICE, INC.
ART DIRECTOR	TIM LARSEN
DESIGNER	JERRY STENBACK, MARK KUNDMANN
CLIENT	CONNECT COMPUTER COMPANY
SOFTWARE	QUARKXPRESS, ADOBE PHOTOSHOP, ALDUS FREEHAND
HARDWARE	MAC IICI

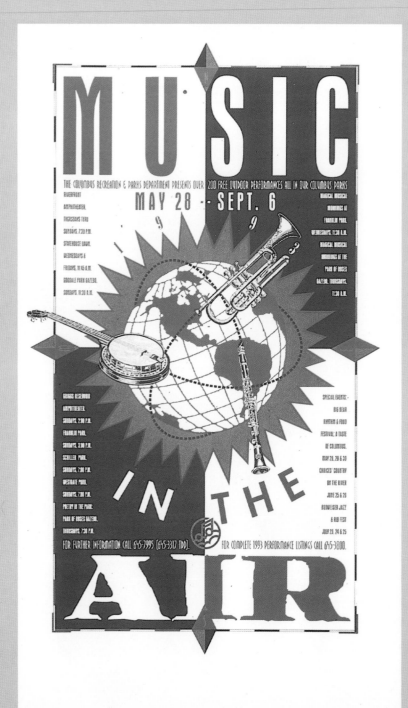

DESIGN FIRM RICKABAUGH GRAPHICS
ART DIRECTOR ERIC RICKABAUGH
DESIGNER ERIC RICKABAUGH
CLIENT THE CITY OF COLUMBUS
SOFTWARE ALDUS FREEHAND, ADOBE PHOTOSHOP
HARDWARE MAC IICI

DESIGN FIRM RICKABAUGH GRAPHICS
ART DIRECTOR ERIC RICKABAUGH
DESIGNER ERIC RICKABAUGH
CLIENT THE CITY OF COLUMBUS
SOFTWARE ALDUS FREEHAND, ADOBE PHOTOSHOP
HARDWARE MAC IICI

DESIGN FIRM VAUGHN WEDEEN CREATIVE
ART DIRECTOR RICK VAUGHN
DESIGNER RICK VAUGHN
COMPUTER PRODUCTION CHIP WYLY
CLIENT QC GRAPHICS
SOFTWARE ALDUS FREEHAND, ADOBE PHOTOSHOP
HARDWARE MAC IICX WITH RADIUS ROCKET

DESIGN FIRM HORNALL ANDERSON DESIGN WORKS
ART DIRECTOR JACK ANDERSON
DESIGNER JACK ANDERSON, HEIDI HATLESTAD, DENISE WEIR
CLIENT SIX SIGMA
SOFTWARE ALDUS FREEHAND
HARDWARE MAC QUADRA 800, SUPER MAC THUNDAR II LIGHT

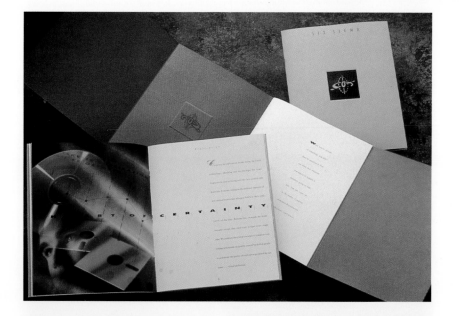

DESIGN FIRM HORNALL ANDERSON DESIGN WORKS
ART DIRECTOR JACK ANDERSON
DESIGNER JACK ANDERSON, JULIE TANAGI-LOCK, JULIE KEENAN, LIAN NG
CLIENT STARBUCKS COFFEE COMPANY
SOFTWARE QUARKXPRESS, ADOBE PHOTOSHOP
HARDWARE MAC QUADRA 800, SUPER MAC THUNDAR II LIGHT

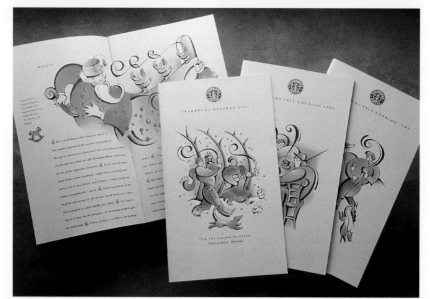

DESIGN FIRM HORNALL ANDERSON DESIGN WORKS
ART DIRECTOR JACK ANDERSON
DESIGNER JACK ANDERSON, JULIE TANAGI-LOCK, LIAN NG, JOHN ANICKER
CLIENT STARBUCKS COFFEE COMPANY
SOFTWARE QUARKXPRESS, ALDUS FREEHAND
HARDWARE MAC QUADRA 800, SUPER MAC THUNDAR II LIGHT

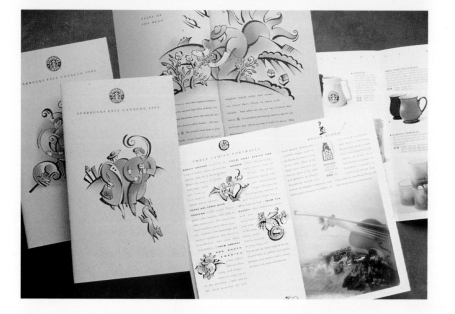

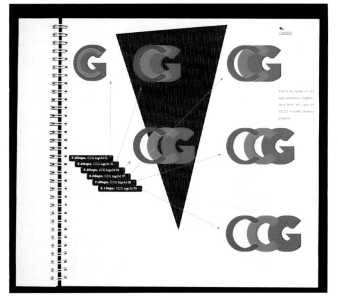

21

DESIGN FIRM O & J DESIGN
ART DIRECTOR ANDRZEJ J. OLEJNICZAK
DESIGNER ANDRZEJ J. OLEJNICZAK
CLIENT CORPORATE COMMUNICATION GROUP
SOFTWARE ADOBE ILLUSTRATOR, QUARKXPRESS
HARDWARE MAC IICI

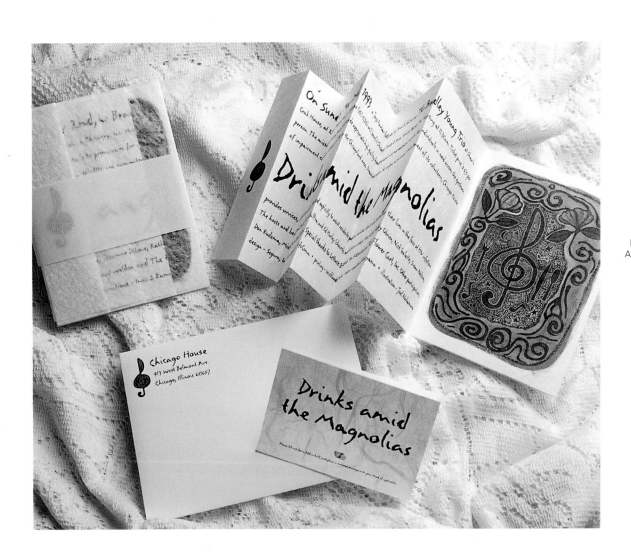

DESIGN FIRM SEGURA INC.
ART DIRECTOR CARLOS SEGURA
DESIGNER CARLOS SEGURA
CLIENT GIMCRACKS
SOFTWARE ADOBE PHOTOSHOP, QUARKXPRESS,
 ADOBE ILLUSTRATOR, ADOBE STREAMLINE,
 ALTSYS FONTOGRAPHER
HARDWARE MAC QUADRA 800

CD Cover

Design Firm	Animus Comunicacao
Art Director	Rique Nitzsche
Designer	Felicio Torres
Client	EMI - Odeon
Software	Corel Draw
Hardware	IBM PC 486

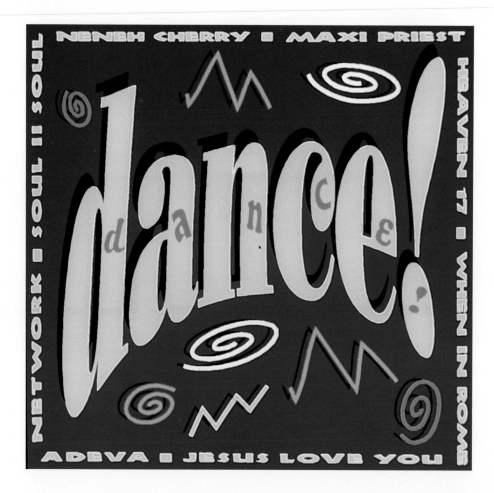

Design Firm	Shields Design
Art Director	Charles Shields
Designer	Charles Shields
Client	Fresno Graphics Group
Software	Adobe Illustrator, Fontographer
Hardware	Mac

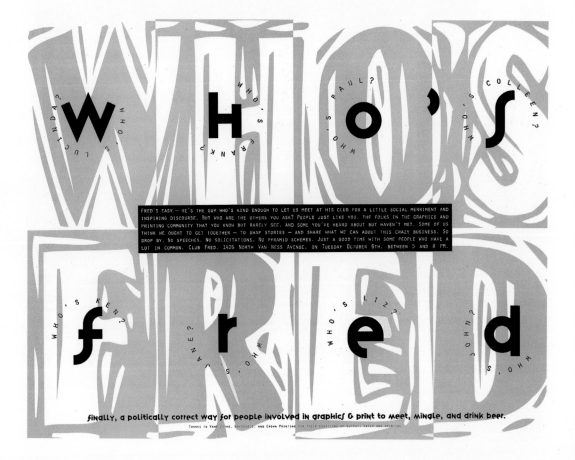

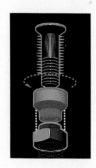

HI-SHEAR INDUSTRIES INC.

1991　　ANNUAL　　REPORT

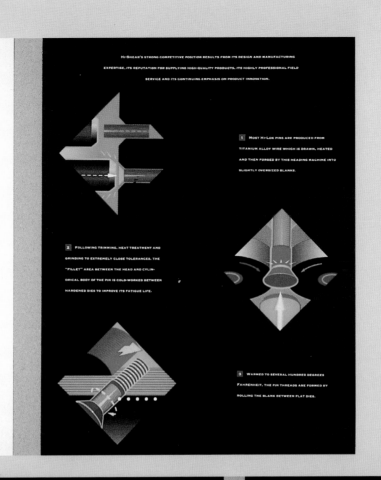

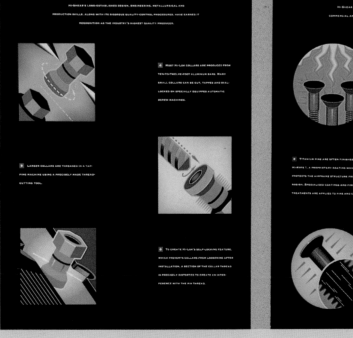

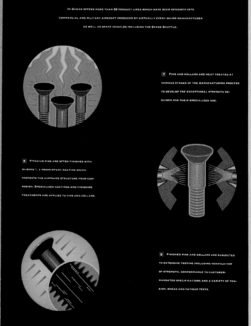

DESIGN FIRM　THE GRAPHIC EXPRESSION, INC.
ART DIRECTOR　STEPHEN FERRARI
CLIENT　HI-SHEAR INDUSTRIES, INC.
SOFTWARE　ADOBE ILLUSTRATOR
HARDWARE　MAC IICI

DESIGNER DAN GONZALEZ
SOFTWARE ADOBE ILLUSTRATOR
HARDWARE MAC IICI

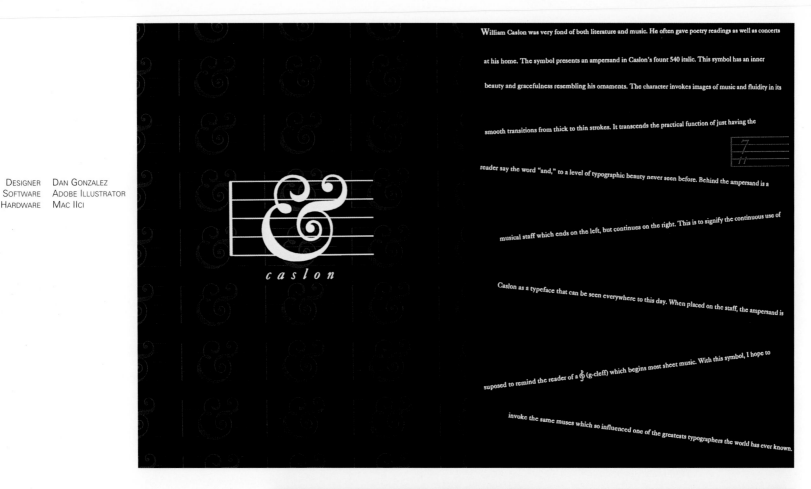

William Caslon was very fond of both literature and music. He often gave poetry readings as well as concerts at his home. The symbol presents an ampersand in Caslon's fount 540 italic. This symbol has an inner beauty and gracefulness resembling his ornaments. The character invokes images of music and fluidity in its smooth transitions from thick to thin strokes. It transcends the practical function of just having the reader say the word "and," to a level of typographic beauty never seen before. Behind the ampersand is a musical staff which ends on the left, but continues on the right. This is to signify the continuous use of Caslon as a typeface that can be seen everywhere to this day. When placed on the staff, the ampersand is suposed to remind the reader of a 𝄞 (g-cleff) which begins most sheet music. With this symbol, I hope to invoke the same muses which so influenced one of the greatests typographers the world has ever known.

DESIGN FIRM JIM LANGE DESIGN
ART DIRECTOR JIM LANGE DESIGN
DESIGNER JIM LANGE DESIGN
CLIENT SPORT MART
SOFTWARE ADOBE ILLUSTRATOR
HARDWARE MAC

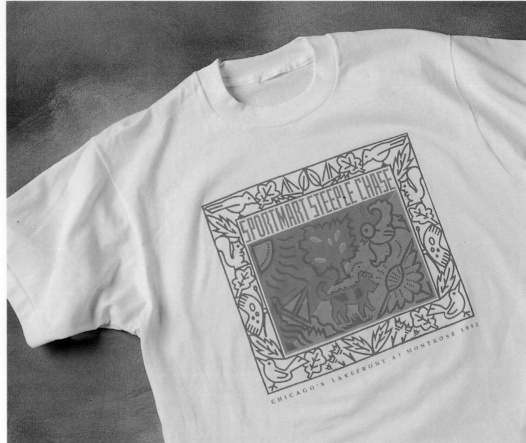

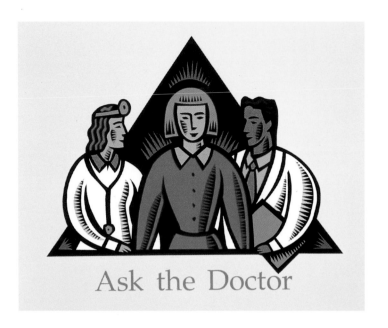

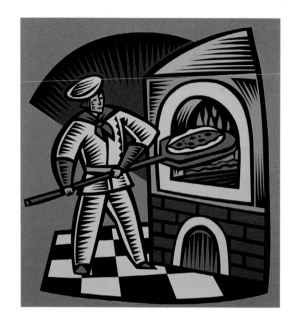

ASK THE DOCTOR

DESIGN FIRM	MIRES DESIGN
ART DIRECTOR	SCOTT MIRES
DESIGNER	TRACY SABIN
CLIENT	SCRIPPS CLINIC
SOFTWARE	ART EXPRESSION
HARDWARE	AMIGA 2000

PIAZZA PIZZA

DESIGN FIRM	MIRES DESIGN
ART DIRECTOR	SCOTT MIRES
DESIGNER	TRACY SABIN
CLIENT	PIAZZA PIZZA
SOFTWARE	ART EXPRESSSION
HARDWARE	AMIGA 2000

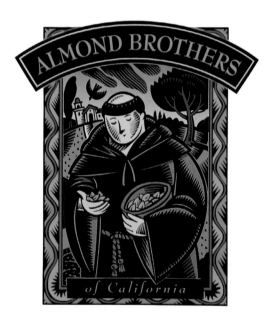

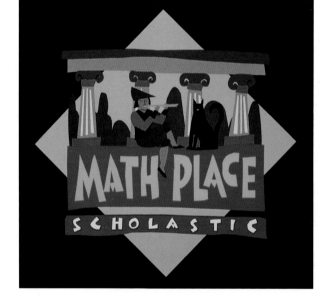

ALMOND BROTHERS

DESIGN FIRM	FOOTE, CONE & BELDING
ART DIRECTOR	BRUCE RITTER
DESIGNER	TRACY SABIN
CLIENT	ALMOND COUNCIL OF CALIFORNIA
SOFTWARE	TV PAINT, AD PRO
HARDWARE	AMIGA 2000

MATH PLACE

DESIGN FIRM	MIRES DESIGN
ART DIRECTOR	SCOTT MIRES
DESIGNER	TRACY SABIN
CLIENT	SCHOLASTIC
SOFTWARE	ART EXPRESSION
HARDWARE	AMIGA 2000

PAULA SCHER

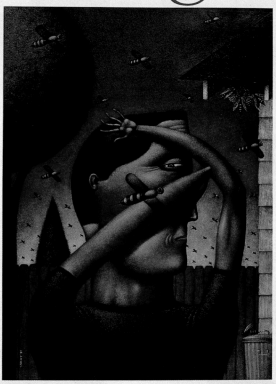

Rough

The Summer Issue

TOM CURRY
Illustrator

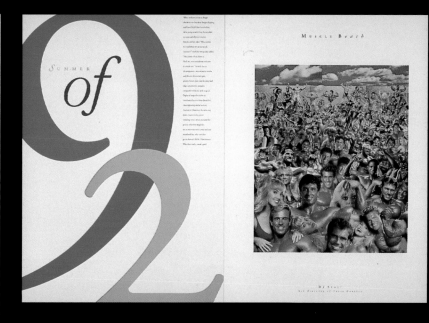

SUMMER OF 92

MUSCLE BEACH

DESIGN FIRM FOCUS 2
ART DIRECTOR SHAWN FREEMAN, TODD HART
DESIGNER SHAWN FREEMAN, TODD HART
CLIENT DALLAS SOCIETY OF VISUAL COMMUNICATIONS
SOFTWARE QUARKXPRESS
HARDWARE MAC IICX

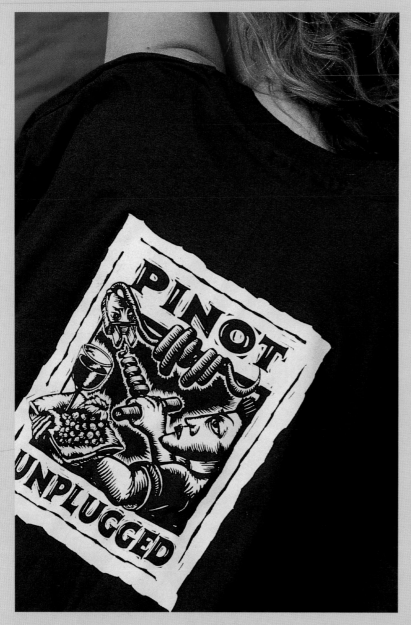

DESIGN FIRM	WALCOTT-AYERS GROUP
ART DIRECTOR	JIM WALCOTT-AYERS
DESIGNER	LAURA KERBYSON, JIM WALCOTT-AYERS
CLIENT	BOUCHAME VINEYARDS
SOFTWARE	ADOBE ILLUSTRATOR
HARDWARE	MAC IIFX

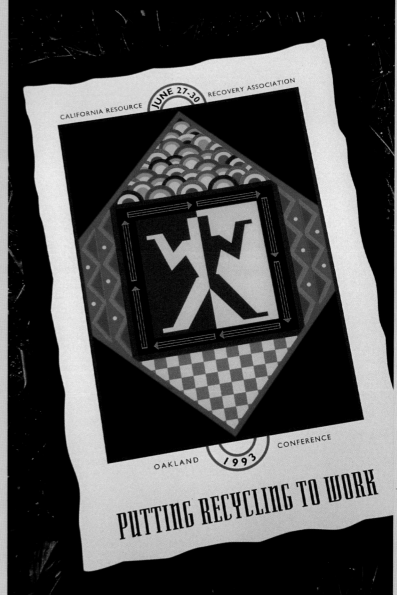

DESIGN FIRM	WALCOTT-AYERS GROUP
ART DIRECTOR	JIM WALCOTT-AYERS
DESIGNER	MEGHAN MAHLER, JIM WALCOTT-AYERS
CLIENT	CALIFORNIA RESOURCE RECOVERY ASSOC.
SOFTWARE	ADOBE ILLUSTRATOR
HARDWARE	MAC IICI

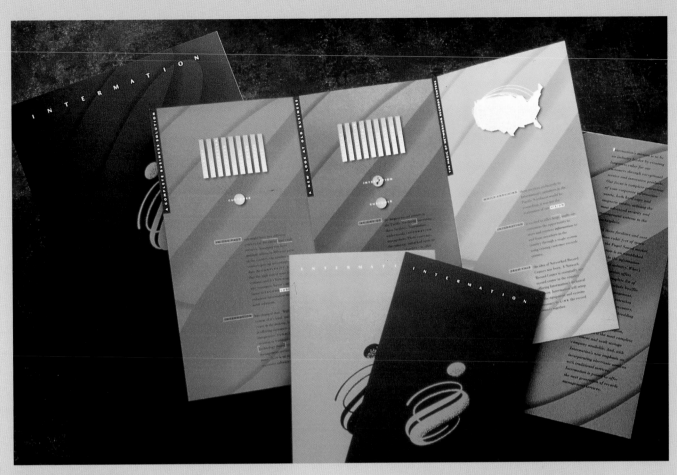

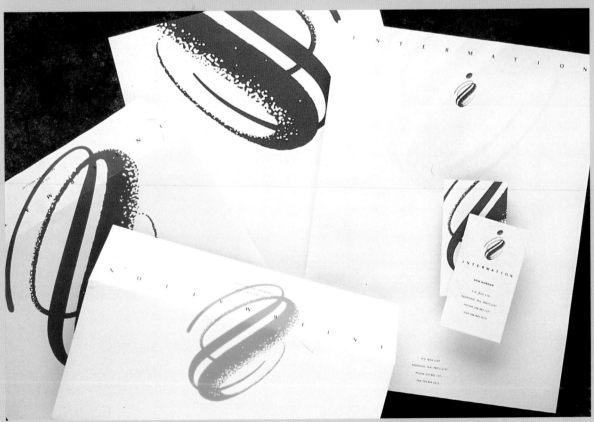

DESIGN FIRM HORNALL ANDERSON DESIGN WORKS
ART DIRECTOR JACK ANDERSON
DESIGNER JACK ANDERSON, LEO RAYMUNDO
CLIENT INTERMATION
SOFTWARE ALDUS FREEHAND
HARDWARE MAC QUADRA 800,
SUPER MAC THUNDAR II LIGHT

Catch the wave

DON'T LET SLICK OR TRENDY DESIGN FOOL

YOU JUMPING ON THE BANDWAGON IS OK

AS LONG AS YOU KNOW WHO'S DRIVING

wave

TITLE WAVE STUDIOS² BECAUSE SOMETIMES

THE BANDWAGON NEEDS A TUNE UP

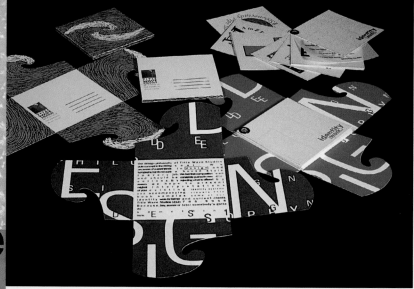

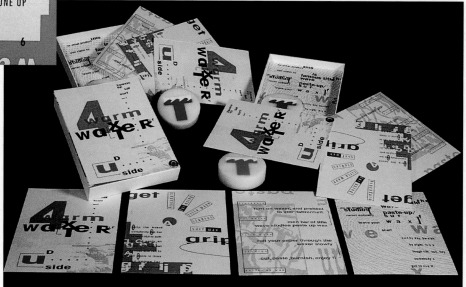

DESIGNER DOUG BARTOW
SOFTWARE QUARKXPRESS, ADOBE ILLUSTRATOR, ADOBE PHOTOSHOP
HARDWARE MAC

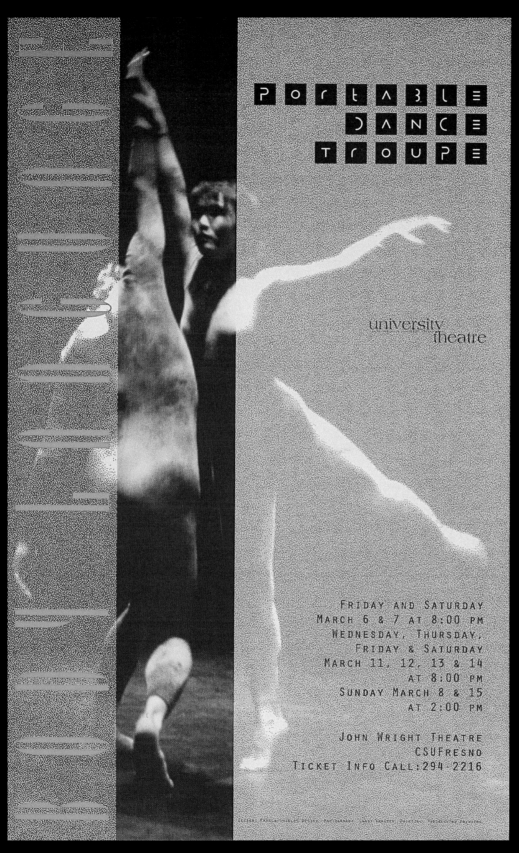

PORTABLE
DANCE
TROUPE

university
theatre

FRIDAY AND SATURDAY
MARCH 6 & 7 AT 8:00 PM
WEDNESDAY, THURSDAY,
FRIDAY & SATURDAY
MARCH 11, 12, 13 & 14
AT 8:00 PM
SUNDAY MARCH 8 & 15
AT 2:00 PM

JOHN WRIGHT THEATRE
CSUFRESNO
TICKET INFO CALL:294-2216

DESIGN FIRM	SHIELDS DESIGN
ART DIRECTOR	CHARLES SHIELDS
DESIGNER	CHARLES SHIELDS
CLIENT	CITY DANCE
SOFTWARE	ADOBE ILLUSTRATOR, ADOBE PHOTOSHOP
HARDWARE	MAC

Ad 1 — Michael Graves

Michael Graves
Professor of Aeronautical
and Astronautical Engineering
Cambridge, Massachusetts

"How I Got Started with *Mathematica*."

A few years ago, I was working with another engineer at Boeing on a project

for the Air Force that required extensive symbolic manipulations. In particular, we were looking for series solutions to partial differential equations. My colleague said, "Why don't we try *Mathematica*? It does exactly what we want to do." But I'd never used it.

We had programmed the equations in Fortran and were getting numerical instability errors. We knew that was a mistake—the equations were well be-

haved, the matrices were nonsingular. But because of the limits of the significant digits we got with Fortran, we were running into this problem. Although I hadn't used it, I was willing to try sorting out the problem with *Mathematica*.

Using *Mathematica*, we discovered that indeed this very large system of equations wasn't singular, that it did have a solvable set. So we rewrote our code knowing everything was working OK.

I was impressed. *Mathematica* was able to handle the symbolic manipulations we needed and more. It solved differential equations and gave exact solutions. It made plots for me on the screen. It gave me output that I could read and understand, and the input was very natural. I'm used to Macintosh systems, but even on a workstation I could work with *Mathematica* in a more or less intuitive way.

Now I turn to *Mathematica* whenever I've got any questions

about symbolic math. I don't worry about the limits of significant digits in Fortran, C, or any other programming language because with *Mathematica* I can maintain hundreds of significant digits with no concerns about inaccuracies or errors. *Mathematica* was the answer to my problems. ❋

Normal mode of vibration of a clamped plate

CONVEX, D…
(ULTRIX and…
HP Apollo, IB…
NeXT, Silicon…
SPARCstation…
Prices in U.S…
Educational…
Orders: 1-800…

Mathematica
The Standard…

Ad 2 — Michael Mezzino, Jr.

Michael Mezzino, Jr.
Professor of Mathematics
Houston, Texas

"How I Got Started with *Mathematica*."

A colleague on our staff who works in electro-optics told us about something new called *Mathematica*. None of us had seen it, so we were curious. When the math department bought a computer, we also got a copy of *Mathematica*. The whole department started experimenting.

Of course, everybody began with the graphics—draw a few nice surfaces and

commands. A logician experimented with the logic capabilities. We all went in different directions to satisfy our own particular interests.

I guess I was the first one in the mathematics department to jump into the programming side of *Mathematica* because that's what interests me.

For instance, I wrote a package for

series solutions to ordinary differential equations. I got the routines working and taught myself *Mathematica* with that task in mind. It's easier to learn if you have a specific objective— that way you aren't overwhelmed by everything *Mathematica* can do. Later,

bring them into Calculus 3 class to impress your students. But eventually people were drawn in by the other features. One of the number theorists played with the numerical

I wrote PhaseScope, a tool that interacts with *Mathematica*, for our course in ordinary differential equations.

Now we're getting grants to build a computer math lab, and we're using

Mathematica i… The Notebook front end is what hook… mulas with g… Notebooks c… discovery of … anything else…

Mathematica
Microsoft W…
DG AViiON…
VMS), DEC …
IBM RISC S…
Silicon Graph…
stations.
Prices in U.S…
Educational…
Orders: 1-80…

Mathematica
The Standar…

Ad 3 — Lynn Purser

Lynn Purser
Orbital Dynamics Analyst
Huntsville, Alabama

"How I Got Started with *Mathematica*."

I admit, when I first read about *Mathematica*, I was a little skeptical. I guess mathematicians are like anybody else. Sort of like auto workers being replaced by robots—some mathematicians were skeptical of something that might replace them. So when my firm offered an in-house training seminar on *Mathematica*, I decided to see what all the talk was about.

That class was fun. I tried to do things beyond what the teacher was covering—the rudimentary stuff about *Mathematica* syntax. I wanted to do animation and play with the graphics. I was taken with the visual dimension of it.

Simulations of the dynamics of the shuttle.

Working on NASA projects, I have to solve problems and present my solutions in a way others can understand. People respond to a visualization better than abstract equations, hand-waving, or scribbling on a blackboard. With *Mathematica's* graphical capability, especially animation, I can make a dynamic presentation that gives a concrete idea of what I'm talking about.

Then there's the symbolic power. For example, the first project I tackled with *Mathematica* involved a nasty algebraic equation. I solved it on my own and then let *Mathematica* solve it. We both came up with the same answer. But my solution took a few hours and *Mathematica's* took a few minutes.

Now I use *Mathematica* regularly. I don't think it will ever replace mathematicians; it acts as an assistant of sorts. It helps you explore and develop concepts, by handling the tedious details. In that way, you're free to concentrate on more important things. ❋

Intersection of fields of sweep of two sensors in the shuttle payload bay.

Mathematica is available for: MS-DOS, Microsoft Windows, Macintosh, CONVEX, DG AViiON, DEC VAX (ULTRIX and VMS), DEC RISC, HP 9000, HP Apollo, IBM RISC System/6000, MIPS, NeXT, Silicon Graphics, Sony, Sun-3, and SPARCstations.
Prices in U.S. and Canada start at $595. Educational discounts are available.
Orders: 1-800-441-MATH

Mathematica 2.0
The Standard for Technical Computing

DESIGN FIRM WOLFRAM RESEARCH, INC./PUBLICATIONS DEPARTMENT
ART DIRECTOR JOHN BONADIES
DESIGNER JOHN BONADIES, JODY JASINSKI
CLIENT WOLFRAM RESEARCH, INC.
SOFTWARE WOLFRAM MATHEMATICA, QUARKXPRESS,
ADOBE ILLUSTRATOR, ADOBE PHOTOSHOP
HARDWARE MAC IIFX, SCITEX
3-D GRAPHICS WERE CREATED WITH
WOLFRAM MATHEMATICA.

105
MINUTES

of

Pregnant

A HIGH-SCHOOL SENIOR WHO IS DUMPED BY A FOOTBALL STAR BECAUSE HE FEARS FOR HIS PENDING SCHOLARSHIP. WHEN HER DAD DROPS DEAD AT THE NEWS, SHE FINDS A DUBIOUS SAVIOR, A BOOKISH FELLOW WHO CAN'T EVEN CLEAN A BATHROOM TO HIS DAD'S SATISFACTION. DROLLNESS ON SCREEN CAN SOMETIMES BE HAD CHEAPLY, BUT A PERFECT CAST IS TOUGHER TO BANKROLL. THIS ORIGINAL HAS ***BOTH, ENOUGH TO DIFFUSE THE SMUGNESS THAT SEEMS TO LINGER IN ITS SOUL. R

16 mm celluloid film

slightly twisted comedy

SUNDAY • FEBRUARY 21 • 1993 • 8 PM • DESALLE

DESIGN FIRM CRANBROOK ACADEMY OF ART
DESIGNER BRIAN SCHORN
CLIENT CRANBROOK ACADEMY OF ART
SOFTWARE QUARKXPRESS
HARDWARE MAC IICI

DESIGN FIRM CRANBROOK ACADEMY OF ART
DESIGNER BRIAN SCHORN
CLIENT CRANBROOK ACADEMY OF ART
SOFTWARE QUARKXPRESS
HARDWARE MAC IICI

DESIGN FIRM ART & FUNCTION
DESIGNER JOSE NERIA DELANO
CLIENT EDICIONES PEDRO ARELLANO
HARDWARE MAC CENTRIS 650

DESIGN FIRM	JAVIER ROMERO DESIGN GROUP
ART DIRECTOR	JAVIER ROMERO
DESIGNER	JAVIER ROMERO, GARY ST. CLARE
CLIENT	SPECIAL PROMOTION
SOFTWARE	ADOBE ILLUSTRATOR
HARDWARE	MAC QUADRA

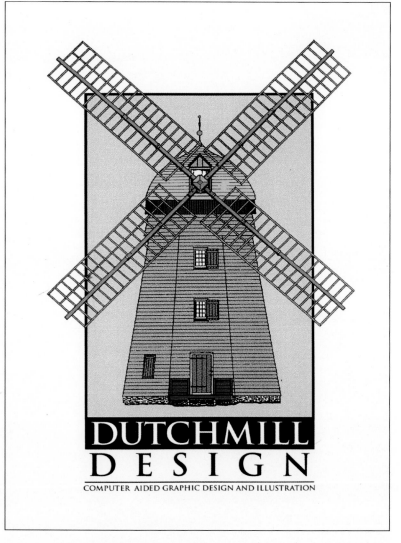

DESIGN FIRM HORNALL ANDERSON DESIGN WORKS
ART DIRECTOR JACK ANDERSON
DESIGNER JACK ANDERSON, CLIFF CHUNG, DAVID BATES
CLIENT MICROSOFT CORPORATION
SOFTWARE ALDUS PAGEMAKER, ALDUS FREEHAND
HARDWARE MAC QUADRA 800, SUPER MAC THUNDAR II LIGHT

DESIGN FIRM DUTCHMILL DESIGN
ART DIRECTOR PATTI J. LACHANCE
DESIGNER PATTI J. LACHANCE
CLIENT SELF-PROMOTION
SOFTWARE ALDUS FREEHAND
HARDWARE MAC IICI

STRATEGY PROGRAM
DESIGN FIRM HANDLER GROUP INC.
ART DIRECTOR MARK J. HANDLER, TOM DOLLE
DESIGNER TOM DOLLE, JANE PATERSON
CLIENT MARK J. HANDLER
SOFTWARE QUARKXPRESS
HARDWARE MAC QUADRA 840AD

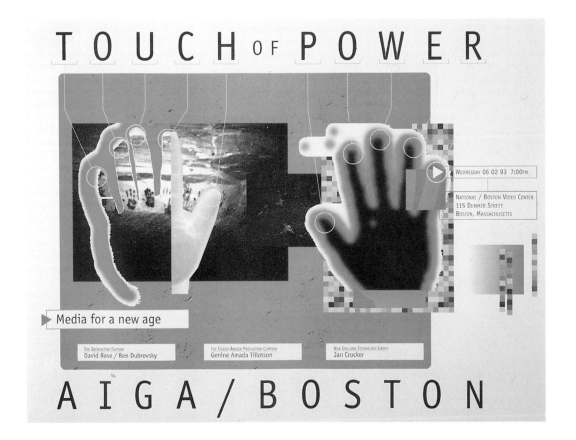

DESIGN FIRM MARC ENGLISH: DESIGN
ART DIRECTOR MARC ENGLISH
DESIGNER MARC ENGLISH
CLIENT AIGA/BOSTON
SOFTWARE QUARKXPRESS, ADOBE PHOTOSHOP
HARDWARE MAC CENTRIS 650

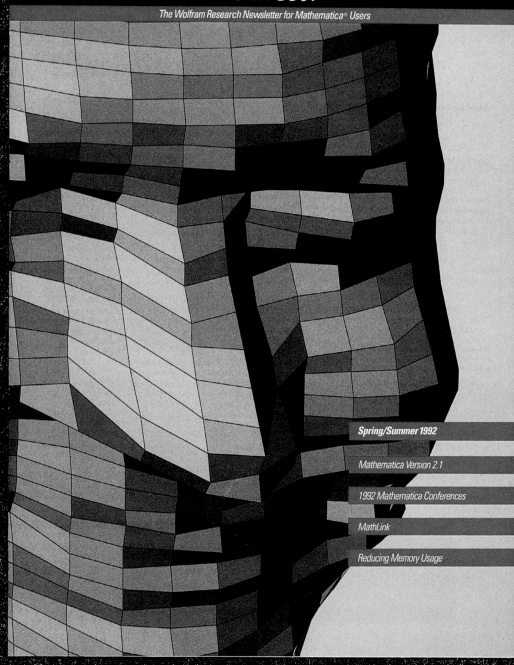

DESIGN FIRM WOLFRAM RESEARCH, INC./PUBLICATIONS DEPARTMENT
ART DIRECTOR JOHN BONADIES
DESIGNER JOHN BONADIES, ANDRE KUZNIAREK
CLIENT WOLFRAM RESEARCH, INC.
SOFTWARE WOLFRAM MATHEMATICA, QUARKXPRESS, ADOBE ILLUSTRATOR, ADOBE PHOTOSHOP
HARDWARE MAC IIFX, SCITEX

ALL GRAPHICS WERE CREATED WITH WOLFRAM MATHEMATICA.

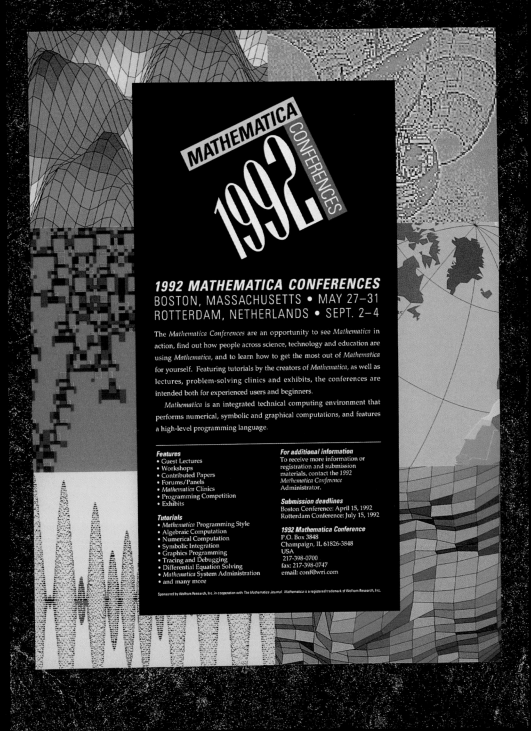

MATHEMATICA 1992 CONFERENCES

1992 MATHEMATICA CONFERENCES
BOSTON, MASSACHUSETTS • MAY 27–31
ROTTERDAM, NETHERLANDS • SEPT. 2–4

The *Mathematica Conferences* are an opportunity to see *Mathematica* in action, find out how people across science, technology and education are using *Mathematica*, and to learn how to get the most out of *Mathematica* for yourself. Featuring tutorials by the creators of *Mathematica*, as well as lectures, problem-solving clinics and exhibits, the conferences are intended both for experienced users and beginners.

Mathematica is an integrated technical computing environment that performs numerical, symbolic and graphical computations, and features a high-level programming language.

Features
• Guest Lectures
• Workshops
• Contributed Papers
• Forums/Panels
• *Mathematica* Clinics
• Programming Competition
• Exhibits

Tutorials
• *Mathematica* Programming Style
• Algebraic Computation
• Numerical Computation
• Symbolic Integration
• Graphics Programming
• Tracing and Debugging
• Differential Equation Solving
• *Mathematica* System Administration
• and many more

For additional information
To receive more information or registration and submission materials, contact the *1992 Mathematica Conference* Administrator.

Submission deadlines
Boston Conference: April 15, 1992
Rotterdam Conference: July 15, 1992

1992 Mathematica Conference
P.O. Box 3848
Champaign, IL 61826-3848
USA
217-398-0700
fax: 217-398-0747
email: conf@wri.com

Sponsored by Wolfram Research, Inc. in cooperation with *The Mathematica Journal*. *Mathematica* is a registered trademark of Wolfram Research, Inc.

DESIGN FIRM	WOLFRAM RESEARCH, INC./PUBLICATIONS DEPARTMENT
ART DIRECTOR	JOHN BONADIES
DESIGNER	JOHN BONADIES, JODY JASINSKI
CLIENT	WOLFRAM RESEARCH, INC.
SOFTWARE	WOLFRAM MATHEMATICA, QUARKXPRESS, ADOBE ILLUSTRATOR, ADOBE PHOTOSHOP
HARDWARE	MAC IIFX, SCITEX

ALL GRAPHICS WERE CREATED WITH WOLFRAM MATHEMATICA.

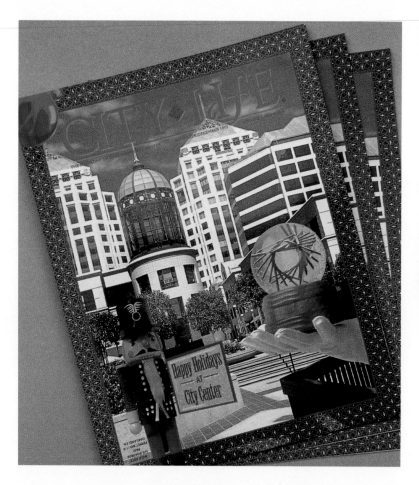

DESIGN FIRM WALCOTT-AYERS GROUP
ART DIRECTOR JIM WALCOTT-AYERS
DESIGNER MEGHAN MAHLER, JIM WALCOTT-AYERS
CLIENT U.S. COURIER
SOFTWARE QUARKXPRESS, ADOBE PHOTOSHOP
HARDWARE MAC CI

DESIGN FIRM WALCOTT-AYERS GROUP
ART DIRECTOR JIM WALCOTT-AYERS
DESIGNER JIM WALCOTT-AYERS
CLIENT BRAMALEA PACIFIC
SOFTWARE ADOBE ILLUSTRATOR, ADOBE PHOTOSHOP
HARDWARE MAC QUADRA 800

THIS WAS COMPOSED FROM SEVEN IMAGES. THE STATUE IN THE COURTYARD WAS DISTORTED AND PLACED IN THE WATER GLOBE; THE SIGN WAS ADDED TO THE NUTCRACKER REFLECTIONS PAINTED ON THE ORNAMENT CREATED IN ADOBE PHOTOSHOP.

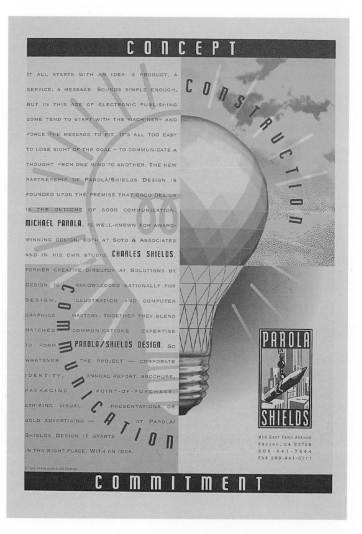

DESIGN FIRM SHIELDS DESIGN
ART DIRECTOR CHARLES SHIELDS
DESIGNER CHARLES SHIELDS
CLIENT PAROLA/SHIELDS DESIGN
SOFTWARE ADOBE ILLUSTRATOR, ADOBE PHOTOSHOP
HARDWARE MAC

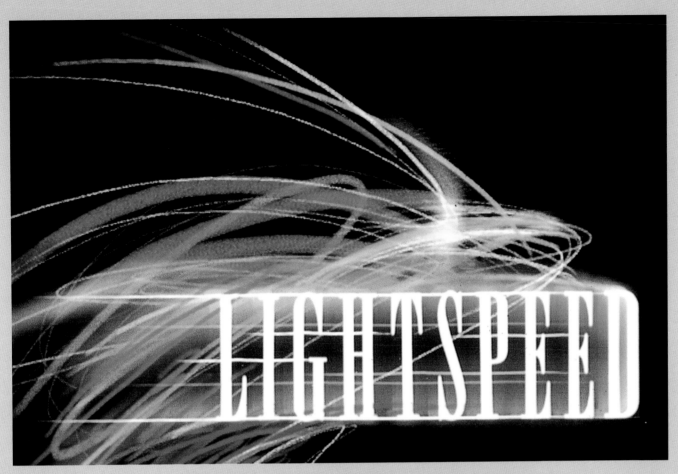

DESIGN FIRM JANET SCABRINI DESIGN INC.
ART DIRECTOR JANET SCABRINI
DESIGNER JANET SCABRINI
CLIENT SILVESTER TAFURO DESIGN
SOFTWARE QUANTEL PAINTBOX
HARDWARE QUANTEL PAINTBOX

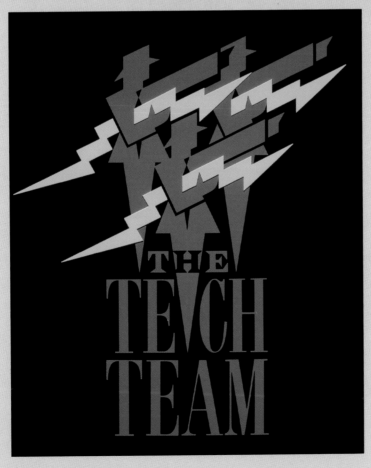

DESIGN FIRM RICKABAUGH GRAPHICS
ART DIRECTOR ERIC RICKABAUGH
DESIGNER ERIC RICKABAUGH
COMPUTER ARTIST TONY MEUSER
CLIENT HUNTINGTON BANKS
SOFTWARE ALDUS FREEHAND
HARDWARE MAC IICI

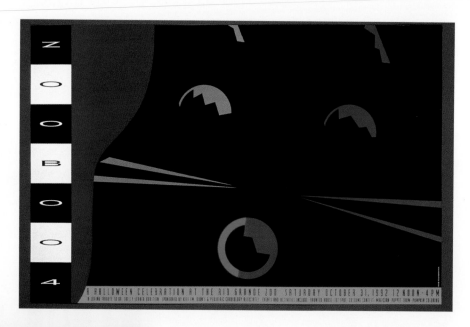

DESIGN FIRM VAUGHN WEDEEN CREATIVE
ART DIRECTOR STEVE WEDEEN
DESIGNER STEVE WEDEEN
COMPUTER PRODUCTION CHIP WYLY
CLIENT GRANDE ZOO
SOFTWARE ADOBE PHOTOSHOP, ALDUS FREEHAND, QUARKXPRESS
HARDWARE MAC IICX WITH RADIUS ROCKET

DESIGN FIRM VAUGHN WEDEEN CREATIVE
ART DIRECTOR DANIEL MICHAEL FLYNN
DESIGNER DANIEL MICHAEL FLYNN
COMPUTER PRODUCTION CHIP WYLY, NATHAN JAMES
CLIENT HORIZON HEALTHCARE CORPORATION
SOFTWARE ALDUS FREEHAND, ADOBE PHOTOSHOP, QUARKXPRESS
HARDWARE MAC IICX WITH RADIUS ROCKET

DESIGN FIRM HORNALL ANDERSON DESIGN WORKS
ART DIRECTOR JOHN HORNALL
DESIGNER JOHN HORNALL, HEIDI HATLESTAD,
JULIA LAPINE, JOHN ANICKER
CLIENT AIRBORNE EXPRESS
SOFTWARE QUARKXPRESS
HARDWARE MAC QUADRA 800, SUPER MAC THUNDAR II LIGHT

ART DIRECTOR	KENT TAYANAKA
DESIGNER	JEFF BRICE
CLIENT	MACWORLD
SOFTWARE	COLORSTUDIO
HARDWARE	MAC II

CD COVER

DESIGN FIRM	ANIMUS COMUNICACAO
ART DIRECTOR	RIQUE NITZSCHE
DESIGNER	FELICIO TORRES
CLIENT	EMI - ODEON
SOFTWARE	COREL DRAW
HARDWARE	IBM PC 486

PRESTON DELIVERS TWINS

Announcing the arrival of our new Minneapolis/St. Paul service

DESIGN FIRM WHITNEY EDWARDS DESIGN
ART DIRECTOR CHARLENE WHITNEY EDWARDS
DESIGNER CHARLENE WHITNEY EDWARDS
CLIENT PRESTON TRUCKING COMPANY
SOFTWARE QUARKXPRESS, ADOBE ILLUSTRATOR
HARDWARE MAC QUADRA 950

PRESTON SERVICE COMES TO THE NORTH COUNTRY

DESIGN FIRM HORNALL ANDERSON DESIGN WORKS
ART DIRECTOR JACK ANDERSON
DESIGNER JACK ANDERSON, BRIAN O'NEILL
CLIENT HORNALL ANDERSON DESIGN WORKS
SOFTWARE ALDUS FREEHAND
HARDWARE MAC QUADRA 800, SUPER MAC THUNDAR II LIGHT

DESIGN FIRM WATT, ROOP & CO.
ART DIRECTOR GREGORY OZNOWICH
DESIGNER GREGORY OZNOWICH
CLIENT THE AMERICAN INSTITUTE OF
GRAPHIC ARTS (AIGA), CLEVELAND
CHAPTER
SOFTWARE ALDUS PAGEMAKER
HARDWARE MAC QUADRA 950

ALL OF THE LAYOUT WAS DONE IN
ALDUS PAGEMAKER, THEN IMAGED
TO PAPER BLOWN UP TO ACTUAL
SIZE. THIS WAS DONE TO MANUALLY
ADJUST LETTER SPACING AT THE
LARGER SIZE.

DESIGN FIRM WATT, ROOP & CO.
ART DIRECTOR GREGORY OZNOWICH
DESIGNER GREGORY OZNOWICH
CLIENT NCR CORPORATION
SOFTWARE ALDUS PAGEMAKER,
ALDUS FREEHAND
HARDWARE MAC QUADRA 950

ALL OF THE LAYOUT WAS DONE IN
ALDUS PAGEMAKER, AND ALL
ILLUSTRATIONS WERE CREATED IN
ALDUS FREEHAND. PHOTOS WERE
SCANNED IN AT LOW RESOLUTION
FOR POSITION ONLY, THEN STRIPPED
IN CONVENTIONALLY.

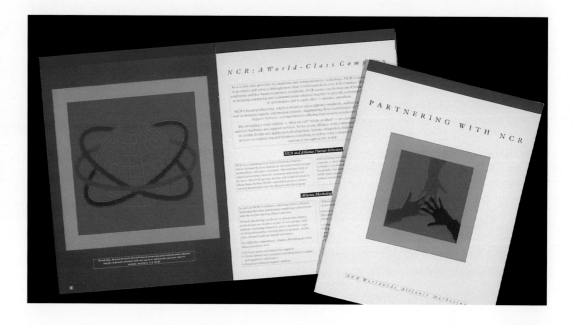

DESIGN FIRM	INTEGRATE INC.
ART DIRECTOR	STEPHEN E. QUINN
DESIGNER	DARRYL LEVERING
CLIENT	MOUNT CARMEL HEALTH VOLUNTEER FAIR
SOFTWARE	ALDUS FREEHAND
HARDWARE	MAC

1 PEOPLE LINKED TO PEOPLE 9

9 3

VOLUNTEER

Share the Spirit

LEARN ABOUT VOLUNTEER OPPORTUNITIES AT THE VOLUNTEER...SHARE THE SPIRIT GATHERING!
ASSOCIATES WILL BE ABLE TO EXPLORE AND
DISCUSS VOLUNTEER OPPORTUNITIES WITH CITYWIDE ORGANIZATIONS.
PARTICIPATE IN THIS IMPORTANT EXCHANGE, AND VOLUNTEER...SHARE THE SPIRIT!

APRIL 26, 1993
MOUNT CARMEL EAST HOSPITAL
11:00 A.M. - 2:00 P.M.
EAST & WEST AUDITORIUM

MAY 7, 1993
MOUNT CARMEL MEDICAL CENTER
11:00 A.M. - 2:00 P.M.
COLLEGE OF NURSING GYMNASIUM

MOUNT CARMEL
HEALTH
The Spirit of Life

LUNCH WILL BE PROVIDED

DESIGN FIRM	MIRES DESIGN
ART DIRECTOR	JOSE SEMANO
DESIGNER	TRACY SABIN
CLIENT	CALIFORNIA CENTER FOR THE ARTS
SOFTWARE	ART EXPRESSION
HARDWARE	AMIGA 2000

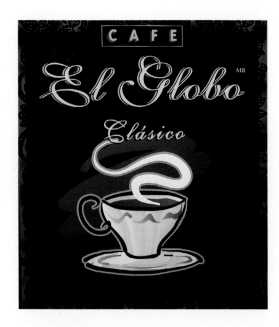

DESIGN FIRM BURGEFF CO.
ART DIRECTOR PATRICK BURGEFF
DESIGNER PATRICK BURGEFF
CLIENT EL GLOBO
SOFTWARE ALDUS FREEHAND, ADOBE PHOTOSHOP
HARDWARE MAC IICI

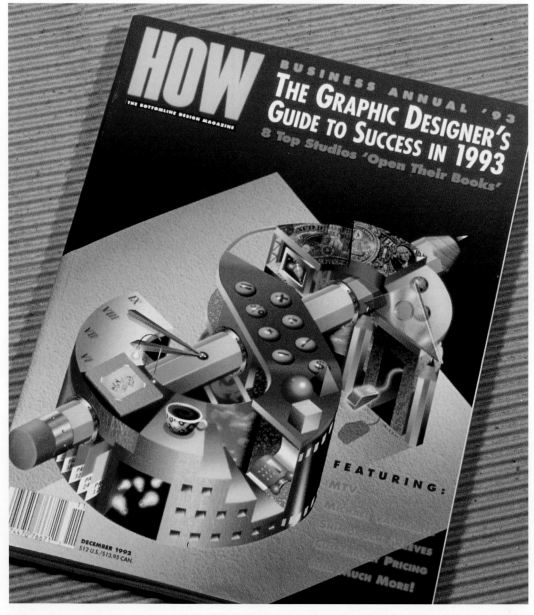

DESIGN FIRM STUDIO MD, GABLE DESIGN GROUP
ART DIRECTOR TONY GABLE, GABLE DESIGN GROUP
 GLENN MITSUI, STUDIO MD
DESIGNER TONY GABLE, GABLE DESIGN GROUP
 GLEN MITSUI, STUDIO MD
ILLUSTRATOR GLENN MITSUI, STUDIO MD
CLIENT HOW MAGAZINE
SOFTWARE ALDUS FREEHAND, ADOBE PHOTOSHOP, RAY DREAM DESIGNER, FRACTAL DESIGN PAINTER
HARDWARE MAC IICX

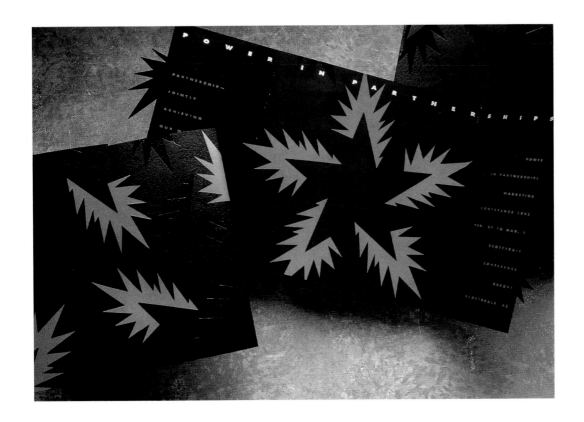

DESIGN FIRM HORNALL ANDERSON
 DESIGN WORKS
ART DIRECTOR JACK ANDERSON
DESIGNER JACK ANDERSON, CLIFF CHUNG,
 SCOTT EGGERS, LEO RAYMUNDO,
 DAVID BATES
CLIENT FOOD SERVICES OF AMERICA
SOFTWARE ALDUS FREEHAND
HARDWARE MAC QUADRA 800,
 SUPER MAC THUNDAR II LIGHT

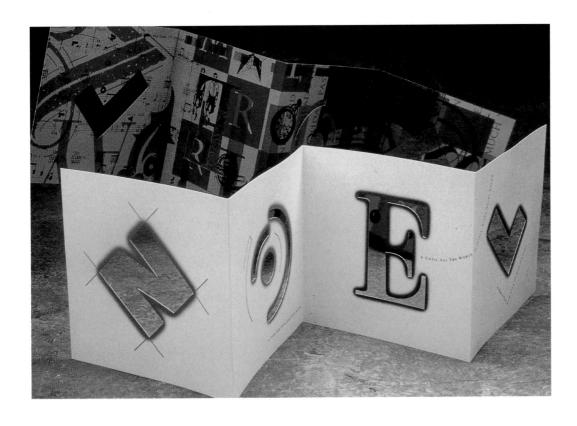

DESIGN FIRM HORNALL ANDERSON
 DESIGN WORKS
ART DIRECTOR JACK ANDERSON
DESIGNER JACK ANDERSON, HEIDI HATLESTAD
CLIENT PRINT NORTHWEST
SOFTWARE ALDUS FREEHAND,
 ADOBE PHOTOSHOP
HARDWARE MAC QUADRA 800,
 SUPER MAC THUNDAR II LIGHT

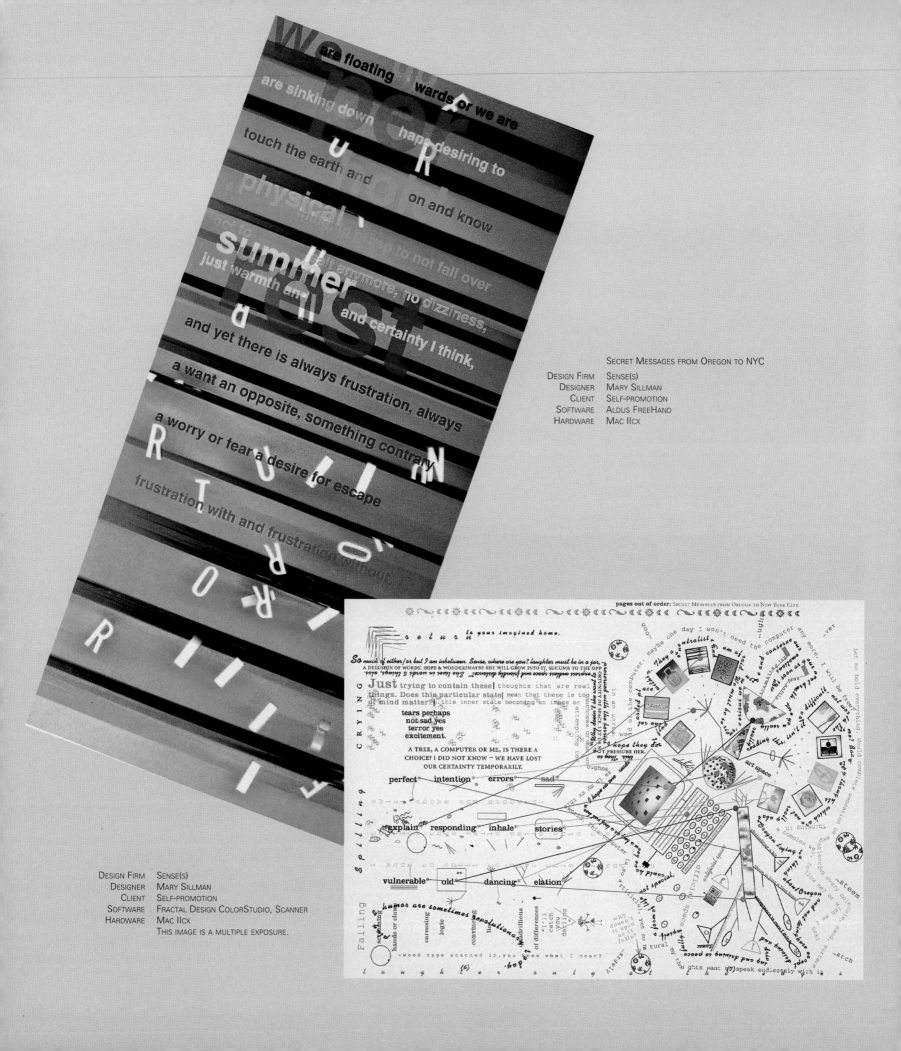

SECRET MESSAGES FROM OREGON TO NYC

DESIGN FIRM	SENSE(S)
DESIGNER	MARY SILLMAN
CLIENT	SELF-PROMOTION
SOFTWARE	ALDUS FREEHAND
HARDWARE	MAC IICX

DESIGN FIRM	SENSE(S)
DESIGNER	MARY SILLMAN
CLIENT	SELF-PROMOTION
SOFTWARE	FRACTAL DESIGN COLORSTUDIO, SCANNER
HARDWARE	MAC IICX
	THIS IMAGE IS A MULTIPLE EXPOSURE.

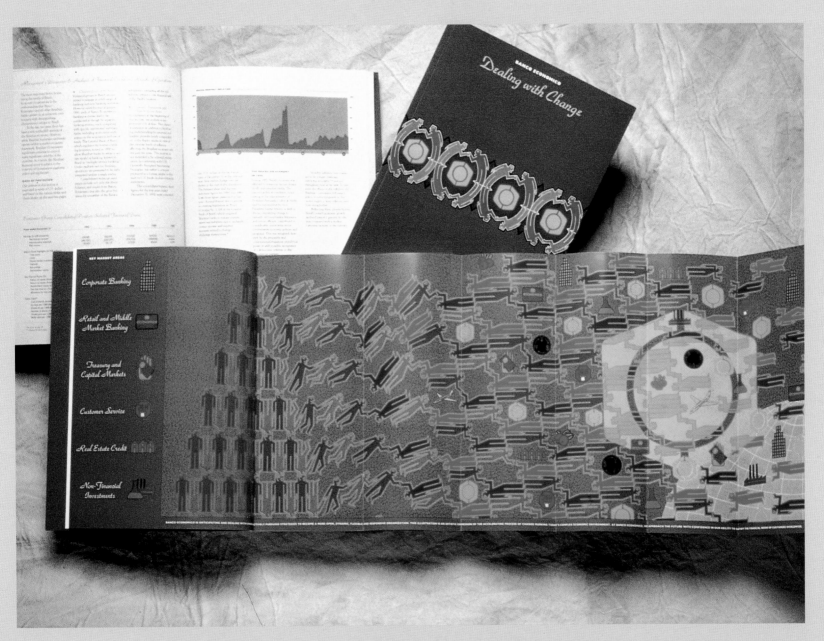

DESIGN FIRM THE WYANT GROUP, INC.
ART DIRECTOR JULIA WYANT
DESIGNER JULIA WYANT, JENNIFER DEITZ
CLIENT BANCO ECONOMICO
SOFTWARE QUARKXPRESS, ADOBE ILLUSTRATOR
HARDWARE MAC IIFX

Illustration & Fine Art

DESIGN FIRM KAVISH & KAVISH
ART DIRECTOR MICHAEL KAVISH
DESIGNER DIANE FENSTER
CLIENT ELECTRONIC ENTERTAINMENT magazine
SOFTWARE ADOBE PHOTOSHOP, PAINT ALCHEMY
HARDWARE MAC IIFX, NEXUS FX ACCELERATOR

DESIGN FIRM JAVIER ROMERO DESIGN GROUP
ART DIRECTOR JAVIER ROMERO
DESIGNER MARTIN FITZPATRICK
CLIENT NEW YORK CITY HOUSING AUTHORITY
SOFTWARE ADOBE ILLUSTRATOR
HARDWARE MAC QUADRA

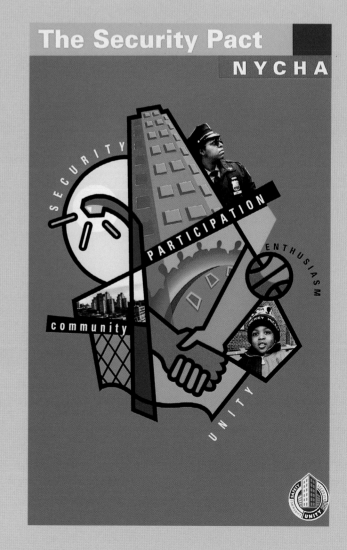

The Security Pact

NYCHA

SECURITY

PARTICIPATION

ENTHUSIASM

community

UNITY

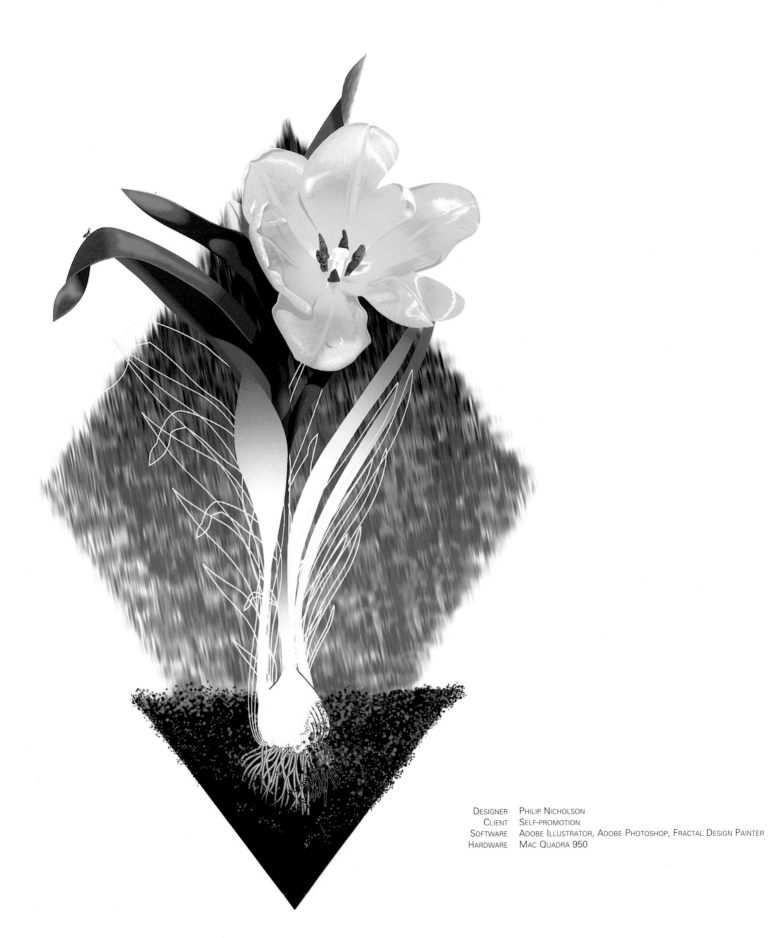

DESIGNER	PHILIP NICHOLSON
CLIENT	SELF-PROMOTION
SOFTWARE	ADOBE ILLUSTRATOR, ADOBE PHOTOSHOP, FRACTAL DESIGN PAINTER
HARDWARE	MAC QUADRA 950

DESIGNER JOHN MODYELEWSKI
CLIENT VICTOR PALAGANO
SOFTWARE ADOBE PHOTOSHOP
HARDWARE MAC

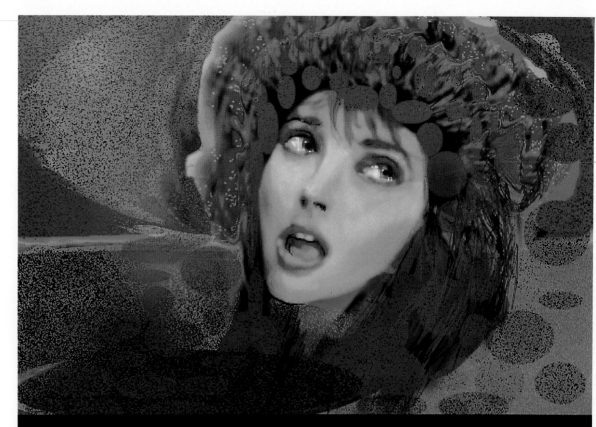

DESIGNER BARBARA NESSIM
SOFTWARE MAC PAINT, POSTERWORKS
HARDWARE MAC IIx, LASERWRITER II

THIS DESIGN WAS HAND PAINTED WITH ACRYLIC.

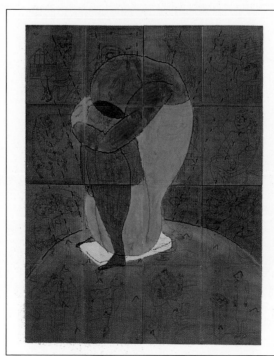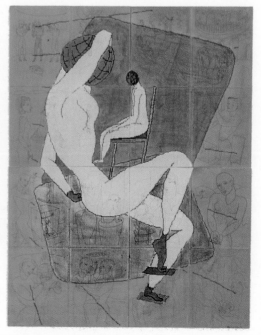

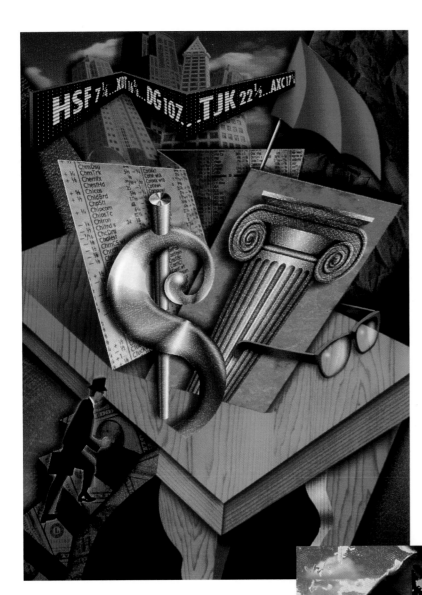

ILLUSTRATION FIRM STUDIO MD
ART DIRECTOR JAY PETROW, BUSINESS WEEK
ILLUSTRATOR GLENN MITSUI
CLIENT BUSINESS WEEK MAGAZINE
SOFTWARE ADOBE PHOTOSHOP, ALDUS FREEHAND, ADOBE ILLUSTRATOR
HARDWARE MAC IICX

ILLUSTRATION FIRM STUDIO MD
ART DIRECTOR KENT TAYANAKA, MACWORLD
ILLUSTRATOR GLENN MITSUI
CLIENT MACWORLD MAGAZINE
SOFTWARE FRACTAL DESIGN PAINTER
HARDWARE MAC IICX

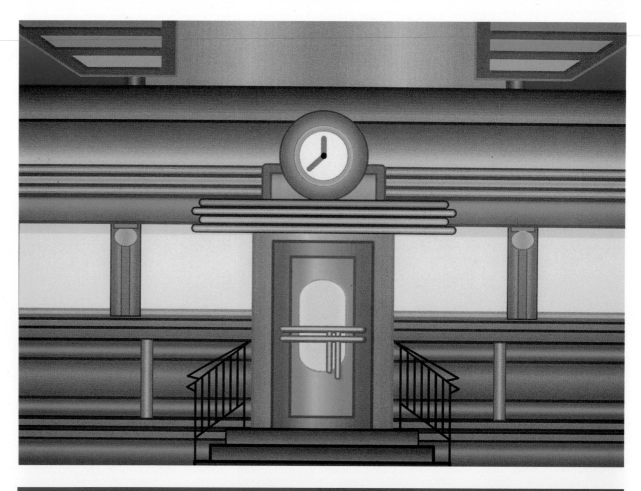

DESIGNER DAVID POSEY
CLIENT SELF-PROMOTION
SOFTWARE GENIGRAPHICS 100D+
HARDWARE GENIGRAPHICS

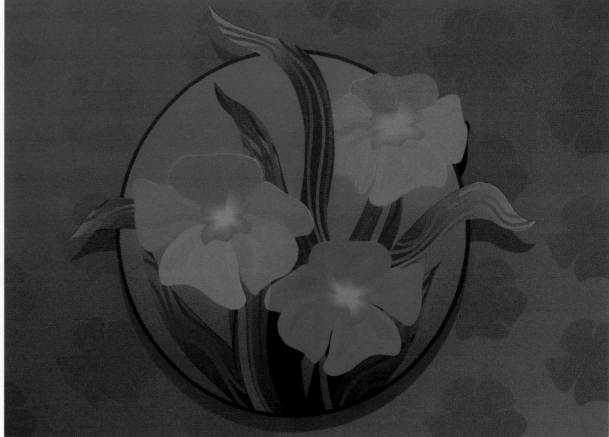

DESIGNER DAVID POSEY
CLIENT SELF-PROMOTION
SOFTWARE GENIGRAPHICS 100D+
HARDWARE GENIGRAPHICS

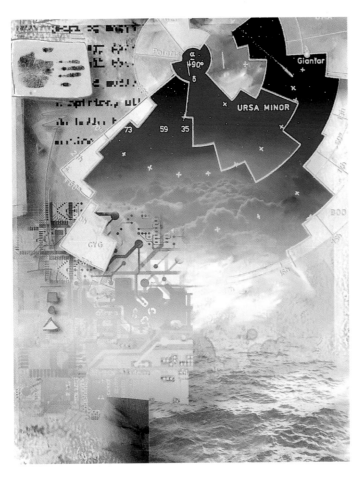

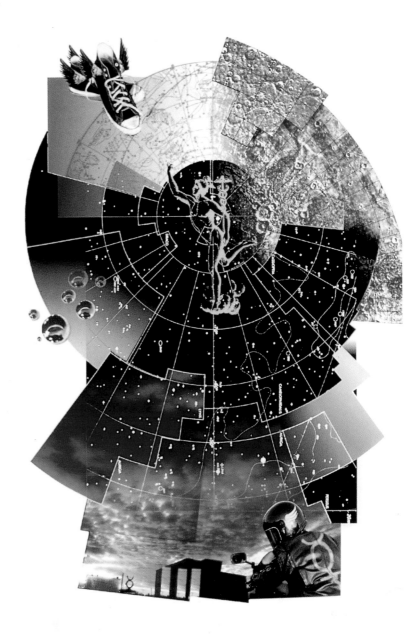

ART DIRECTOR RICHARD HAMILTON
DESIGNER JEFF BRICE
CLIENT I.D.E.A.
SOFTWARE COLORSTUDIO
HARDWARE MAC II

ART DIRECTOR ALEX KATZ
DESIGNER JEFF BRICE
SOFTWARE COLORSTUDIO
HARDWARE MAC II

DESIGN FIRM JACQUELINE COMSTOCK
ART DIRECTOR JACQUELINE COMSTOCK
DESIGNER JACQUELINE COMSTOCK
CLIENT SELF-PROMOTION
SOFTWARE ADOBE PHOTOSHOP, ALDUS GALLERY EFFECTS
HARDWARE MAC IICX, MICROTEK 300 GS SCANNER

THIS IMAGE WAS CREATED DURING THE "ADVANCED IMAGING" WORKSHOP
AT THE CENTER FOR CREATIVE IMAGING IN CAMDEN, MAINE.

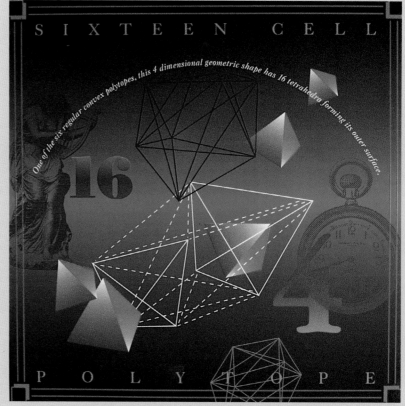

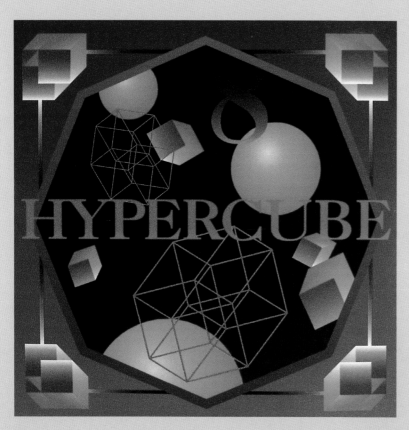

16 CELL

DESIGN FIRM EDUINO J. PEREIRA, GRAPHIC DESIGN
DESIGNER EDUINO J. PEREIRA
CLIENT SELF-PROMOTION
SOFTWARE COREL DRAW
HARDWARE IBM PC 386

ONE OF THE SIX REGULAR CONVEX POLYTOPES; IT HAS 16 TETRAHEDRA ON ITS SURFACE.

HYPERCUBE

DESIGN FIRM EDUINO J. PEREIRA, GRAPHIC DESIGN
DESIGNER EDUINO J. PEREIRA
CLIENT SELF-PROMOTION
SOFTWARE COREL DRAW

THIS IS A 4-DIMENSIONAL REPRESENTATION OF A CUBE

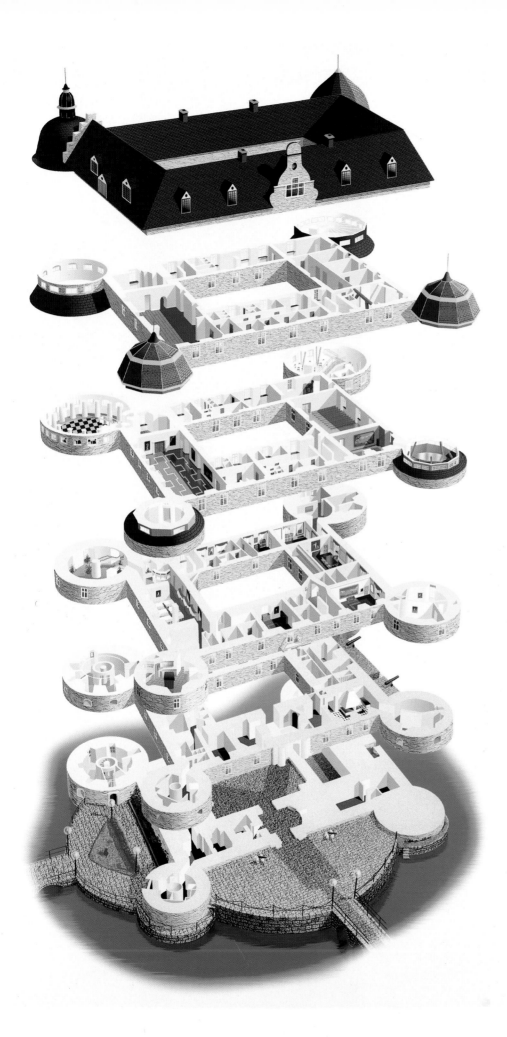

DESIGN FIRM BO LILJEDAL REKLAMBYRA
ART DIRECTOR PER-IVAR FROJO
DESIGNER PHILIP NICHOLSON
CLIENT OREBRO SLOTT
SOFTWARE ADOBE ILLUSTRATOR, ADOBE DIMENSIONS,
FRACTAL DESIGN PAINTER
HARDWARE MAC QUADRA 950

THE PAINT FACTORY

DESIGNER CHRISTOPHER PALLOTTA
SOFTWARE ALDUS FREEHAND, FRACTAL DESIGN
PAINTER, ADOBE PHOTOSHOP
HARDWARE MAC

LANDSCAPE

DESIGNER CHRISTOPHER PALLOTTA
SOFTWARE ADOBE PHOTOSHOP
HARDWARE MAC

INDUSTRIAL VORTEX

DESIGNER CHRISTOPHER PALLOTTA
SOFTWARE ADOBE PHOTOSHOP, FRACTAL
DESIGN PAINTER
HARDWARE MAC

DESIGNER ERIC B. JOHNSON
SOFTWARE ADOBE PHOTOSHOP
HARDWARE MAC IIFX WITH THUNDERSTORM CARD

DESIGNER ERIC B. JOHNSON
SOFTWARE ADOBE PHOTOSHOP
HARDWARE MAC IIFX WITH THUNDERSTORM CARD

QUIZ SHOW FRAGMENTS

DESIGNER ERIC B. JOHNSON
SOFTWARE ADOBE PHOTOSHOP
HARDWARE MAC IIFX WITH THUNDERSTORM CARD

DESIGN FIRM WALCOTT-AYERS GROUP
ART DIRECTOR JIM WALCOTT-AYERS
DESIGNER JIM WALCOTT-AYERS
CLIENT SELF-PROMOTION
SOFTWARE ADOBE PHOTOSHOP
HARDWARE MAC QUADRA 800

THIS IMAGE IS COMPOSED OF THREE
PHOTOGRAPHS, WITH COLOR
RETOUCHING.

BLUE HEAVEN

DESIGN FIRM INTERACT
ART DIRECTOR GREG VANDER HOUWEN
DESIGNER GREG VANDER HOUWEN
SOFTWARE ADOBE PHOTOSHOP
HARDWARE MAC

DIGITAL ILLUSTRATOR/
PHOTOGRAPHER ANDREW J. HATHAWAY
SOFTWARE ADOBE PHOTOSHOP
HARDWARE MAC IICI

STRAWBERRY BLONDE

DESIGN FIRM RHODA GROSSMAN GRAPHICS
ART DIRECTOR RHODA GROSSMAN
DESIGNER RHODA GROSSMAN
CLIENT THE DIGITAL POND
SOFTWARE FRACTAL DESIGN PAINTER
HARDWARE MAC II, KURTA XGT TABLET,
MIRROR 600 COLOR SCANNER

THE DESIGNER USED AUDREY
HEPBURN'S MOUTH AND INGRID
BERGMAN'S EYES IN THIS IMAGE.

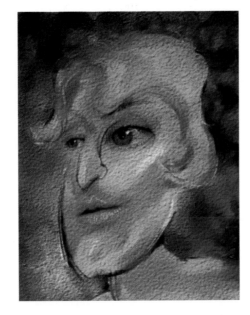

KEITH/SEYBOLD

DESIGN FIRM RHODA GROSSMAN GRAPHICS
ART DIRECTOR RHODA GROSSMAN
DESIGNER RHODA GROSSMAN
CLIENT KURTA CORPORATION
SOFTWARE FRACTAL DESIGN PAINTER
HARDWARE QUADRA, KURTA XGT TABLET

THIS IS AN ON-THE-SPOT DEMO DONE
AT A SEYBOLD TRADE SHOW: THE
VOLUNTEER POSES WHILE THE ARTIST
PAINTS HIM OR HER IN A MIXED
MEDIA STYLE, WHICH INCLUDES
SCANNED ITEMS FROM AN
ELECTRONIC "PORTFOLIO" OF FACIAL
FEATURES.

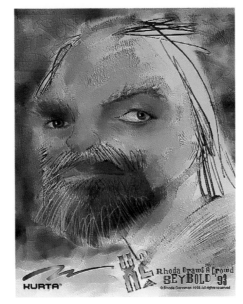

EVELYN/SEYBOLD

DESIGN FIRM RHODA GROSSMAN GRAPHICS
ART DIRECTOR RHODA GROSSMAN
DESIGNER RHODA GROSSMAN
CLIENT KURTA CORPORATION
SOFTWARE FRACTAL DESIGN PAINTER
HARDWARE QUADRA, KURTA XGT TABLET

THIS IMAGE WAS CREATED IN ABOUT
FIFTEEN MINUTES AS A DEMO AT A
SEYBOLD TRADE SHOW.
SOME ELEMENTS, SUCH AS FACIAL
FEATURES AND BORDERS, WERE
SCANNED IN ADVANCE AND THEN
COMBINED WITH PAINTING
TECHNIQUE.

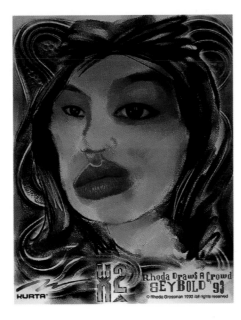

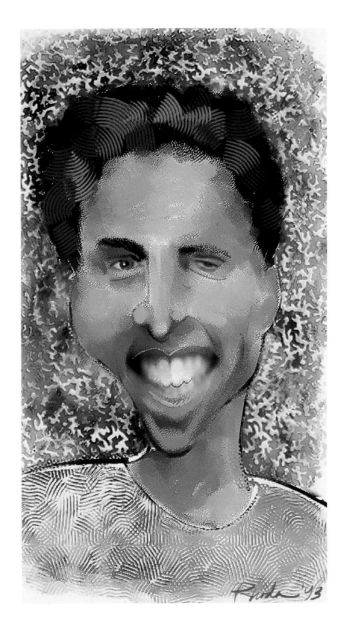

MHJ JOE

DESIGN FIRM RHODA GROSSMAN GRAPHICS
ART DIRECTOR RHODA GROSSMAN
DESIGNER RHODA GROSSMAN
CLIENT MAC HOME JOURNAL
SOFTWARE FRACTAL DESIGN PAINTER
HARDWARE QUADRA, KURTA XGT TABLET,
MIRROR 600 COLOR SCANNER

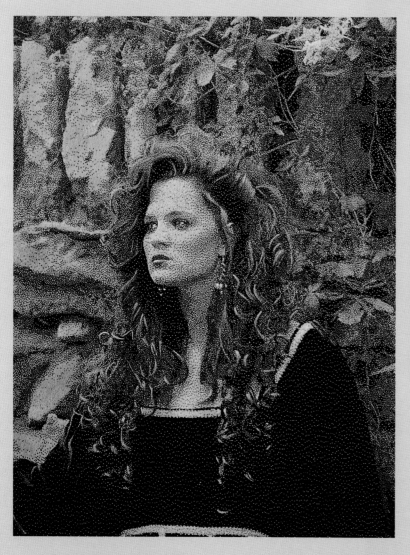

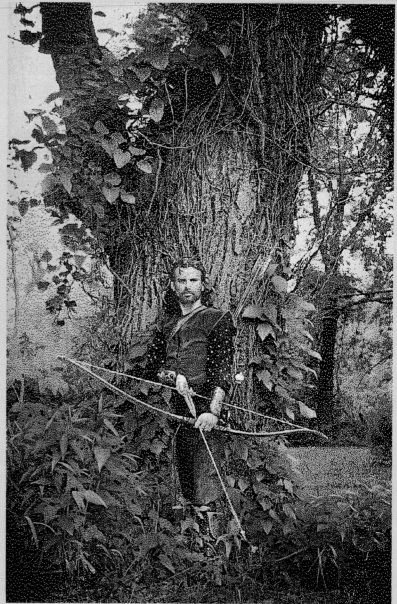

Robin Hood

Design Firm Ken Ramey Illustration
Art Director Ken Ramey
Designer Ken Ramey
Client Self-promotion
Software Adobe Photoshop
Hardware Mac IIfx

This illustration is output on Camson pastel paper and finished with colored pencil and watercolor.

Maid Marian

Design Firm Ken Ramey Illustration
Art Director Ken Ramey
Designer Ken Ramey
Client Self-promotion
Software Adobe Photoshop
Hardware Mac IIfx

This illustration is output on Camson pastel paper and finished with colored pencil and watercolor.

DESIGNER	PHILIP NICHOLSON
CLIENT	SELF-PROMOTION
SOFTWARE	ADOBE ILLUSTRATOR, ADOBE PHOTOSHOP
HARDWARE	MAC QUADRA 950

REFLECTION ON SUBTLE MATTER

DESIGN FIRM INTERACT
ART DIRECTOR GREG VANDER HOUWEN
DESIGNER GREG VANDER HOUWEN
SOFTWARE ADOBE PHOTOSHOP, STRATAVISION 3D, ADOBE ILLUSTRATOR
HARDWARE MAC, WACOM TABLET

UNTITLED ONE

DESIGN FIRM INTERACT
ART DIRECTOR GREG VANDER HOUWEN
DESIGNER GREG VANDER HOUWEN
SOFTWARE ADOBE PHOTOSHOP, STRATAVISION 3D
HARDWARE MAC, WACOM TABLET

CLOUD BURST

DESIGN FIRM INTERACT
ART DIRECTOR GREG VANDER HOUWEN
DESIGNER GREG VANDER HOUWEN
SOFTWARE ADOBE PHOTOSHOP, FRACTAL DESIGN PAINTER, ADOBE ILLUSTRATOR
HARDWARE MAC, WACOM TABLET

CAR CRASH

DESIGNER	CYNTHIA SATLOFF
CLIENT	CENTER FOR CREATIVE IMAGING
SOFTWARE	ADOBE PHOTOSHOP
HARDWARE	MAC IIFX, KODAK RFS SCANNER

VALENTINE

DESIGNER	CYNTHIA SATLOFF
SOFTWARE	ADOBE PHOTOSHOP
HARDWARE	MAC IIFX

CUSTOM BRUSHES IN ADOBE
PHOTOSHOP WERE USED TO CREATE
THIS IMAGE.

DESIGN FIRM JAVIER ROMERO DESIGN GROUP
ART DIRECTOR JAVIER ROMERO
DESIGNER GARY ST. CLARE
CLIENT HYPNOTIC WATCH CO.
SOFTWARE ADOBE ILLUSTRATOR
HARDWARE MAC QUADRA

DESIGN FIRM JAVIER ROMERO DESIGN GROUP
ART DIRECTOR JAVIER ROMERO
DESIGNER GARY ST. CLARE
CLIENT MACUSER MAGAZINE
SOFTWARE ADOBE ILLUSTRATOR
HARDWARE MAC QUADRA

DESIGN FIRM JAVIER ROMERO DESIGN GROUP
ART DIRECTOR JAVIER ROMERO
DESIGNER JAVIER ROMERO
CLIENT IDEAS MAGAZINE
SOFTWARE ADOBE ILLUSTRATOR
HARDWARE MAC QUADRA

DESIGN FIRM ASIA COMPUTERWORLD COMMUNICATION LTD.
ART DIRECTOR ERIC LAM
DESIGNER ERIC LAM
CLIENT PCWORLD (HONG KONG)
SOFTWARE STRATAVISION3D
HARDWARE MAC IICI

DESIGN FIRM ASIA COMPUTERWORLD COMMUNICATION LTD.
ART DIRECTOR ERIC LAM
DESIGNER ERIC LAM
CLIENT PCWORLD (HONG KONG)
SOFTWARE ADOBE PHOTOSHOP, ALIAS SKETCH
HARDWARE MAC IICI

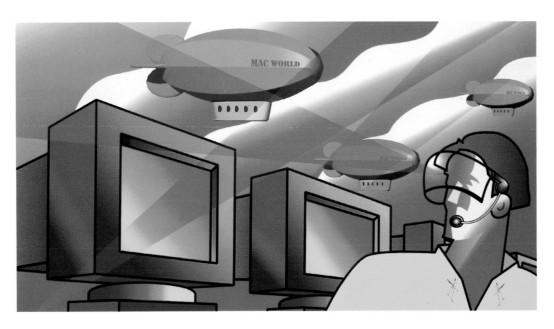

DESIGN FIRM ASIA COMPUTERWORLD
COMMUNICATION LTD.
ART DIRECTOR ERIC LAM
DESIGNER ERIC LAM
CLIENT PCWORLD (HONG KONG)
SOFTWARE ADOBE ILLUSTRATOR, STRATAVISION3D
HARDWARE MAC IICI

DESIGN FIRM MAX STUDIO
ART DIRECTOR MAX ALLERS
DESIGNER MAX ALLERS
CLIENT ZELLERBACK PAPER CO.
SOFTWARE ADOBE PHOTOSHOP
HARDWARE MAC IIFX

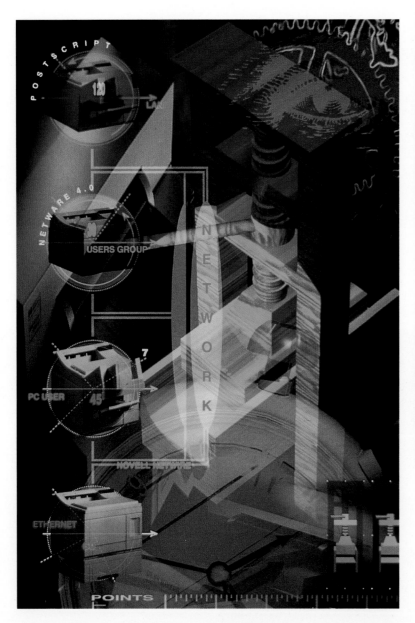

DESIGN FIRM ASIA COMPUTERWORLD COMMUNICATION LTD.
ART DIRECTOR ERIC LAM
DESIGNER ERIC LAM
CLIENT PCWORLD (HONG KONG)
SOFTWARE STRATAVISION3D, ADOBE PHOTOSHOP, ALIAS SKETCH, ALDUS FREEHAND
HARDWARE MAC IICI

DESIGN FIRM ASIA COMPUTERWORLD COMMUNICATION LTD.
ART DIRECTOR ERIC LAM
DESIGNER ERIC LAM
CLIENT PCWORLD (HONG KONG)
SOFTWARE STRATAVISION3D, ADOBE PHOTOSHOP
HARDWARE MAC IICI

DESIGN FIRM	AXELSSON & CO.
ART DIRECTOR	MATS NILSSON
DESIGNER	PHILIP NICHOLSON
CLIENT	HALLANDSTRAFIKEN
SOFTWARE	FRACTAL DESIGN PAINTER
HARDWARE	MAC QUADRA 950

ZIG
COMPUTER ILLUSTRATOR NANCE PATERNOSTER
SOFTWARE ADOBE PHOTOSHOP
HARDWARE WACOM SD512, MAC IIX

MSHRM
COMPUTER ILLUSTRATOR NANCE PATERNOSTER
SOFTWARE FRACTAL DESIGN PAINTER,
ADOBE PHOTOSHOP
HARDWARE WACOM SD512, MAC IIX

AN ANGELIQUE MOMENT

COMPUTER ILLUSTRATOR	NANCE PATERNOSTER
SOFTWARE	FRACTAL DESIGN PAINTER, ADOBE PHOTOSHOP
HARDWARE	WACOM TABLET, MAC IIX

COMPUTER ILLUSTRATOR	NANCE PATERNOSTER
SOFTWARE	FRACTAL DESIGN PAINTER, ADOBE PHOTOSHOP
HARDWARE	WACOM SD512, MAC IIX

DESIGN FIRM ADAM COHEN/ILLUSTRATOR
ART DIRECTOR CHRISTINA WALKER
DESIGN ASSISTANT SUSSAN GIALLOMBARDO
CLIENT SPEC'S MUSIC/CN WALKER GROUP
SOFTWARE ADOBE PHOTOSHOP
HARDWARE MAC IIFX

THESE ARE THREE OUT OF NINE MURALS CREATED FOR SPEC'S.

ILLUSTRATOR ADAM COHEN
ART DIRECTOR LESLIE SINGER
CLIENT MIS PRESS/HENRY HOLT & CO.
SOFTWARE ADOBE PHOTOSHOP
HARDWARE MAC IIFX

Happy Daffs

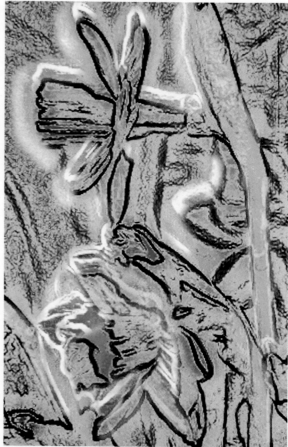

Happy Daffs

Art Director Donald Gambino
Designer Donald Gambino
Client Self-promotion
Software Adobe Photoshop
Hardware Mac Quadra 800

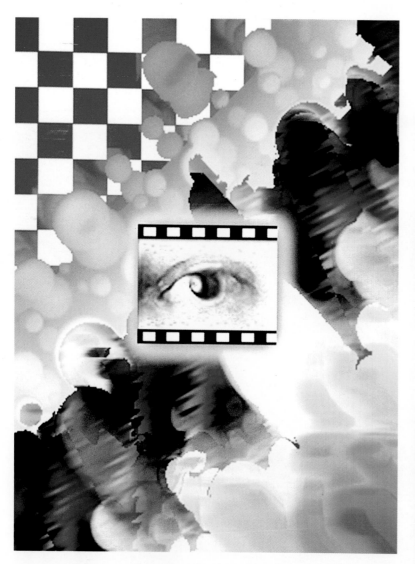

Cinema Eye

Illustrator Donald Gambino
Client Self-promotion
Software Adobe Photoshop
Hardware Mac Quadra 800

Token Wreath

Illustrator Donald Gambino
Client Self-promotion
Software Adobe Photoshop
Hardware Mac Quadra 800

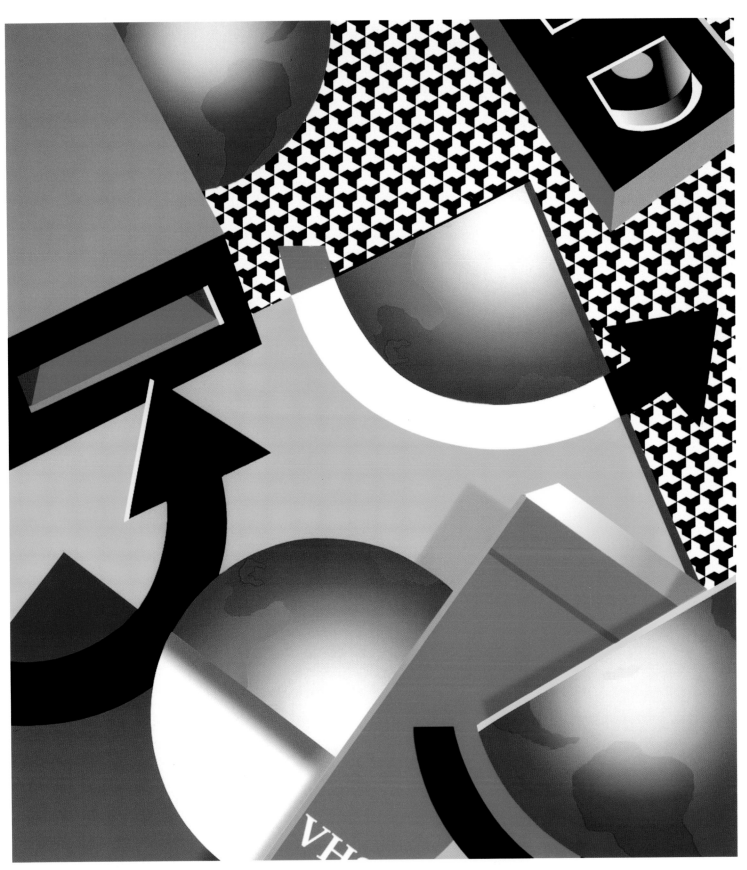

LET'S GO TO THE VIDEO

ILLUSTRATOR	ADAM COHEN
CLIENT	ZIFF-DAVIS PUBLISHERS
SOFTWARE	ADOBE PHOTOSHOP
HARDWARE	MAC IIFX

I-DEN-TI-TIES: Status

DESIGN FIRM	MAUREEN NAPPI, INC.
ART DIRECTOR	MAUREEN NAPPI
DESIGNER	MAUREEN NAPPI
CLIENT	MAUREEN NAPPI
SOFTWARE	QUANTEL
HARDWARE	QUANTEL GRAPHIC PAINTBOX XL

THIS WAS EXHIBITED AT THE ADAMS
ART GALLERY IN DUNKIRK, NEW
YORK AND THROUGHOUT JAPAN.

I-DEN-TI-TIES: THE MIRROR STAGE

DESIGN FIRM	MAUREEN NAPPI, INC.
ART DIRECTOR	MAUREEN NAPPI
DESIGNER	MAUREEN NAPPI
CLIENT	MAUREEN NAPPI
SOFTWARE	QUANTEL
HARDWARE	QUANTEL GRAPHIC PAINTBOX XL

THIS WAS EXHIBITED AT THE ADAMS
ART GALLERY IN DUNKIRK, NEW
YORK, THE THREAD WAXING SPACE,
NEW YORK, AND THROUGHOUT
JAPAN.

DESIGN FIRM	MAUREEN NAPPI, INC.
ART DIRECTOR	MAUREEN NAPPI
DESIGNER	MAUREEN NAPPI
CLIENT	MAUREEN NAPPI
SOFTWARE	QUANTEL
HARDWARE	QUANTEL GRAPHIC PAINTBOX XL

THIS WAS EXHIBITED AT THE ADAMS
ART GALLERY IN DUNKIRK, NEW
YORK AND THROUGHOUT JAPAN.

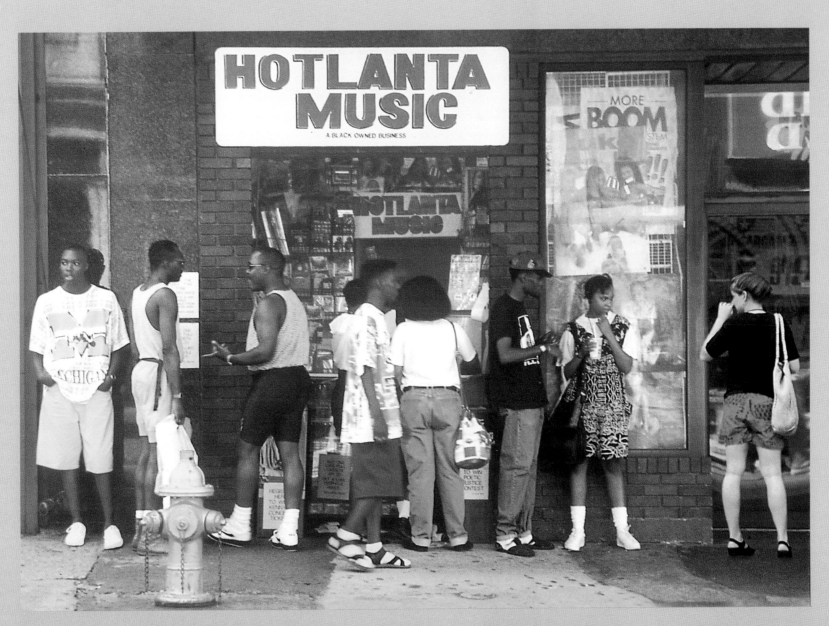

DESIGN FIRM WALCOTT-AYERS GROUP
ART DIRECTOR JIM WALCOTT-AYERS
DESIGNER JIM WALCOTT-AYERS
CLIENT SELF-PROMOTION
SOFTWARE ADOBE PHOTOSHOP
HARDWARE MAC QUADRA 800

TWO DIFFERENT IMAGES WERE USED, WITH CONSIDERABLE RETOUCHING.

METAL - 3317

DESIGN FIRM T2 PRODUCTIONS
ART DIRECTOR KIT MONROE PRAVDA
DESIGNER KIT MONROE PRAVDA
SOFTWARE ADOBE PHOTOSHOP
HARDWARE MAC IICI

WIRED - 3022

DESIGN FIRM T2 PRODUCTIONS
ART DIRECTOR KIT MONROE PRAVDA
DESIGNER KIT MONROE PRAVDA
SOFTWARE ADOBE PHOTOSHOP
HARDWARE MAC IICI

DESIGN FIRM MARK K. HAMEL
ART DIRECTOR MARK K. HAMEL
DESIGNER MARK K. HAMEL
CLIENT PAUL FENMORE
SOFTWARE ADOBE PHOTOSHOP
HARDWARE MAC CENTRIS 610, MAC IIVX

DESIGN FIRM MARK K. HAMEL
ART DIRECTOR MARK K. HAMEL
DESIGNER MARK K. HAMEL
CLIENT SELF-PROMOTION
HARDWARE MAC CENTRIS 610, MAC IIVX

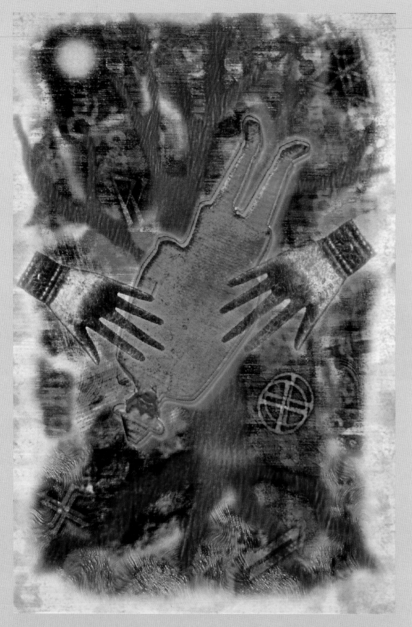

ODIN'S INITIATION

ART DIRECTOR RANDALL HULL
DESIGNER DIANE FENSTER
SOFTWARE FRACTAL DESIGN PAINTER
HARDWARE MAC IIFX, NEXUS FX ACCELERATOR

DESIGNER DAN GONZALEZ
SOFTWARE ALDUS FREEHAND
HARDWARE MAC IICI

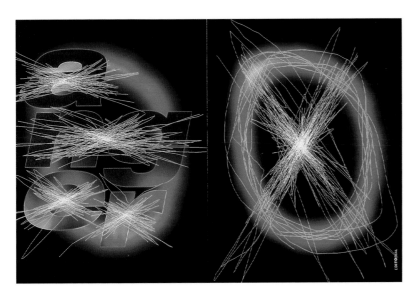

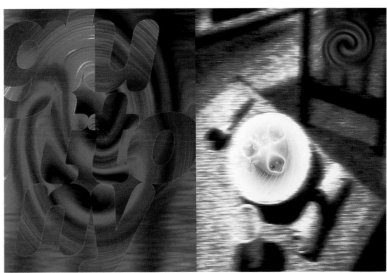

DESIGN FIRM FRANKFURT BALKIND PARTNERS
CREATIVE DIRECTOR KENT HUNTER
DESIGNER RUTH DIENER
ILLUSTRATOR JOHAN VIPPER
CLIENT AMERICAN ILLUSTRATION
SOFTWARE ADOBE PHOTOSHOP
HARDWARE MAC QUADRA 700

THE COVER AND DIVIDER PAGE ILLUSTRATIONS ARE BASED ON THE THEME OF
THE "SEVEN DEADLY SINS" FROM AMERICAN ILLUSTRATION 12.

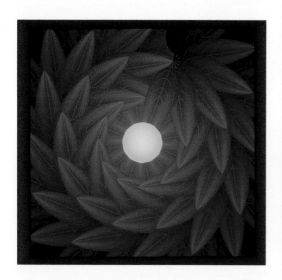

VEGETATIVE VORTEX

DESIGNER CHRISTOPHER PALLOTTA
SOFTWARE ALDUS FREEHAND, ADOBE PHOTOSHOP
HARDWARE MAC

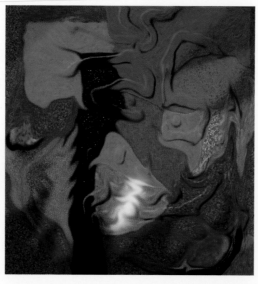

MARDI GRAS

DESIGNER CHRISTOPHER PALLOTTA
SOFTWARE ADOBE PHOTOSHOP
HARDWARE MAC

LISA ON THE ROCKS

DESIGNER CHRISTOPHER PALLOTTA
SOFTWARE ADOBE PHOTOSHOP, FRACTAL DESIGN PAINTER
HARDWARE MAC

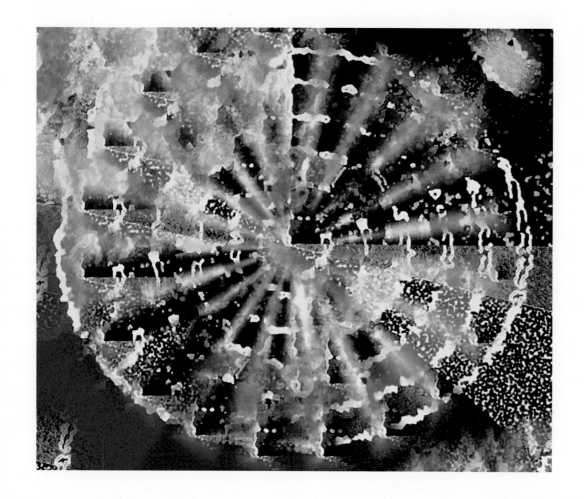

BALL'S EYE FAN

DESIGNER CHRISTOPHER PALLOTTA
SOFTWARE ALDUS FREEHAND, ADOBE PHOTOSHOP
HARDWARE MAC

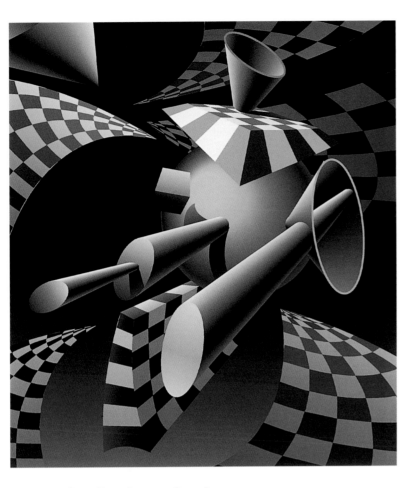

DESIGN FIRM THE MIAMI HERALD
ART DIRECTOR RANDY STANO
DESIGNER DAN GONZÁLEZ
CLIENT THE MIAMI HERALD, SPECIAL OLYMPIC SECTION
SOFTWARE STRATAVISION 3D, ADOBE PHOTOSHOP
HARDWARE MAC IICI

DESIGN FIRM AMPERSAND DESIGN GROUP
ART DIRECTOR DAN GONZÁLEZ
DESIGNER DAN GONZÁLEZ
CLIENT SELF-PROMOTION
SOFTWARE ADOBE ILLUSTRATOR
HARDWARE MAC IICI

DESIGN FIRM THE MIAMI HERALD
ART DIRECTOR RANDY STANO
DESIGNER DAN GONZÁLEZ
CLIENT THE MIAMI HERALD
SOFTWARE ADOBE PHOTOSHOP
HARDWARE MAC IICI

WEDDING DAY

DESIGN FIRM	HATFIELD DESIGN
ART DIRECTOR	LEE HATFIELD
DESIGNER	LEE HATFIELD
CLIENT	SELF-PROMOTION
SOFTWARE	COREL DRAW, FRACTAL DESIGN PAINTER
HARDWARE	IBM PC 486

2 COUSINS

DESIGN FIRM	HATFIELD DESIGN
ART DIRECTOR	LEE HATFIELD
DESIGNER	LEE HATFIELD
CLIENT	SELF-PROMOTION
SOFTWARE	COREL DRAW, FRACTAL DESIGN PAINTER
HARDWARE	IBM PC

SUNDAY IN THE PARK

ART DIRECTOR	RANDY SOWASH
DESIGNER	RANDY SOWASH
SOFTWARE	ADOBE PHOTOSHOP
HARDWARE	MAC IISI

AUTUMN WOODS

ART DIRECTOR	RANDY SOWASH
SOFTWARE	ADOBE PHOTOSHOP, FRACTAL DESIGN PAINTER
HARDWARE	MAC IISI

DESIGNER SUSAN ARONOFF
CLIENT SELF-PROMOTION
SOFTWARE ADOBE PHOTOSHOP, ALDUS FREEHAND
HARDWARE MAC IICI

THESE ILLUSTRATIONS ARE FOR AN ALPHABET BOOK.

DESIGN FIRM STUDIO TWENTY-SIX MEDIA
ART DIRECTOR MARIO HENRI CHAKKOUR
DESIGNER MARIO HENRI CHAKKOUR
CLIENT SELF-PROMOTION
SOFTWARE FRACTAL DESIGN PAINTER
HARDWARE MAC QUADRA 700, WACOM ARTZ TABLET

DESIGN FIRM STUDIO TWENTY-SIX MEDIA
ART DIRECTOR MARIO HENRI CHAKKOUR
DESIGNER MARIO HENRI CHAKKOUR
CLIENT SELF-PROMOTIONTION
SOFTWARE FRACTAL DESIGN PAINTER
HARDWARE MAC QUADRA 700, WACOM ARTZ TABLET

DESIGN FIRM	PENWELL GRAPHICS
ART DIRECTOR	BRUCE SANDERS
ILLUSTRATOR	MARC YANKUS
CLIENT	COMPUTER ARTIST MAGAZINE
SOFTWARE	ADOBE PHOTOSHOP
HARDWARE	MAC QUADRA 950

THIS DESIGN WAS FOR THE COVER OF COMPUTER ARTIST MAGAZINE.

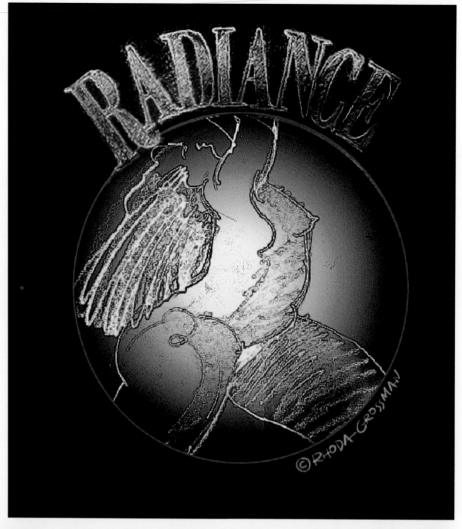

RADIANCE/GLASS

DESIGN FIRM RHODA GROSSMAN GRAPHICS
ART DIRECTOR RHODA GROSSMAN
DESIGNER RHODA GROSSMAN
CLIENT RADIANCE MAGAZINE
SOFTWARE ADOBE PHOTOSHOP, FRACTAL DESIGN PAINTER
HARDWARE MAC II, KURTA XGT TABLET, MIRROR 600 COLOR SCANNER

SELF-PORTRAIT AFTER ESCHER

DESIGN FIRM RHODA GROSSMAN GRAPHICS
ART DIRECTOR RHODA GROSSMAN
DESIGNER RHODA GROSSMAN
CLIENT SELF-PROMOTION
SOFTWARE ADOBE PHOTOSHOP,
 FRACTAL DESIGN PAINTER
HARDWARE MAC II, KURTA XGT TABLET,
 MIRROR 600 COLOR SCANNER

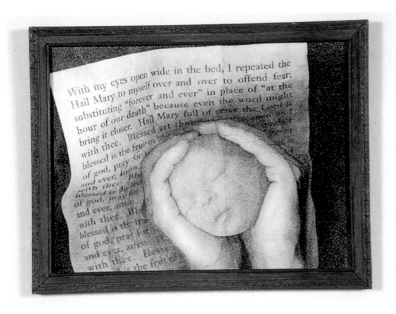

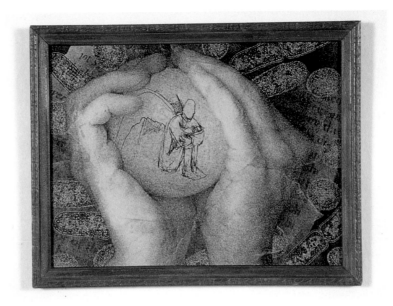

HAIL MARY

ARTIST KATHLEEN CHMELEWSKI
SOFTWARE ADOBE PHOTOSHOP
HARDWARE MAC IICI, MICROTEK 600 S2

ANGEL

ARTIST KATHLEEN CHMELEWSKI
SOFTWARE ADOBE PHOTOSHOP
HARDWARE MAC IICI, MICROTEK 600 S2

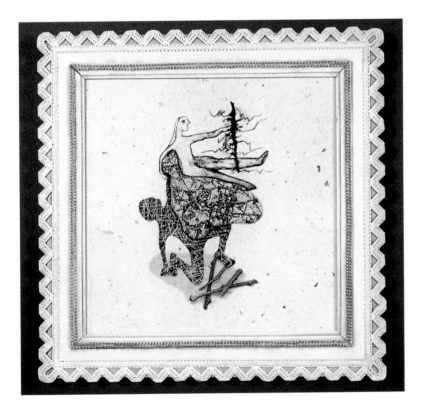

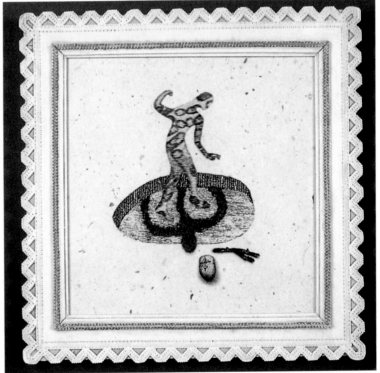

LIGHTNING BOLT

ARTIST KATHLEEN CHMELEWSKI
SOFTWARE ADOBE PHOTOSHOP
HARDWARE MAC IICI, MICROTEK 600 S2

PICKING IT UP

ARTIST KATHLEEN CHMELEWSKI
SOFTWARE ADOBE PHOTOSHOP
HARDWARE MAC IICI, MICROTEK 600 S2

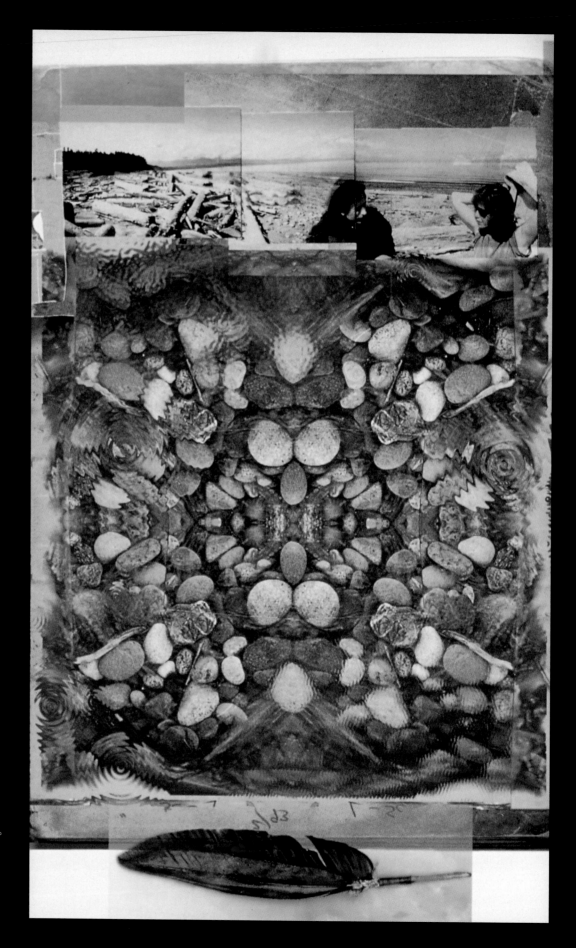

DESIGNER JEFF BRICE
CLIENT SELF-PROMOTION
SOFTWARE COLORSTUDIO, ADOBE PHOTOSHOP
HARDWARE MAC II

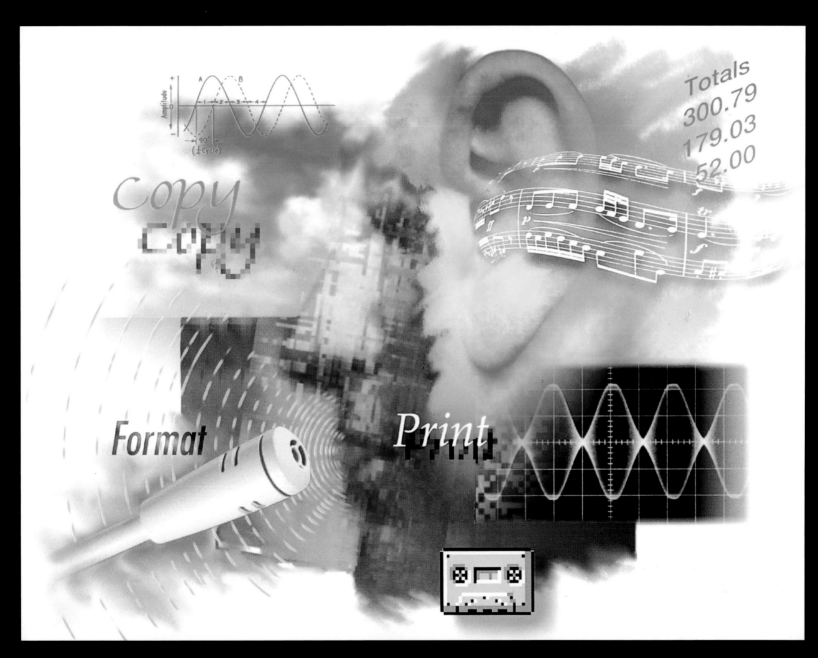

ART DIRECTOR	GREG ERIKSON
DESIGNER	JEFF BRICE
CLIENT	MICROSOFT
SOFTWARE	COLORSTUDIO, ADOBE PHOTOSHOP
HARDWARE	MAC II

DESIGNER JEFF BRICE
CLIENT SELF-PROMOTION
SOFTWARE ADOBE PHOTOSHOP, COLORSTUDIO, KAI'S POWER TOOLS
HARDWARE MAC II

DESIGNER JEFF BRICE
CLIENT SELF-PROMOTION
SOFTWARE COLORSTUDIO
HARDWARE MAC II

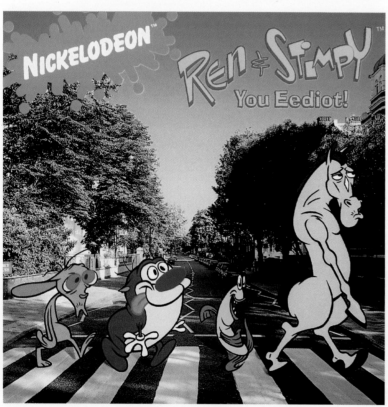

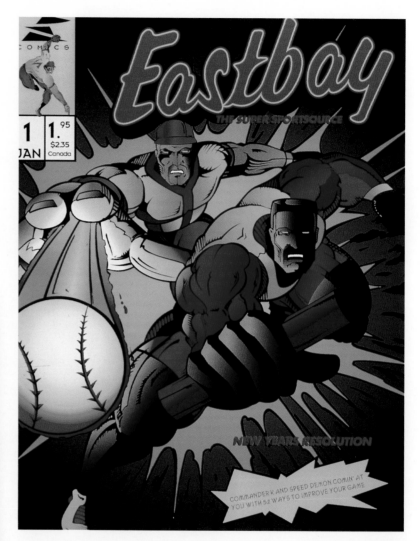

DESIGN FIRM NICKELODEON ACME CREATIVE GROUP
ART DIRECTOR DAVID VOGLER
DESIGNER COREY EDMONDS MILLEN
CLIENT NICKELODEON
SOFTWARE ADOBE PHOTOSHOP, QUARKXPRESS
HARDWARE MAC QUARDA 950

DESIGN FIRM EASTBAY DESIGN STUDIO
DESIGNER DAVID BLAKE
CLIENT EASTBAY INC.
SOFTWARE ADOBE ILLUSTRATOR, ADOBE STREAMLINE
HARDWARE MAC IICI

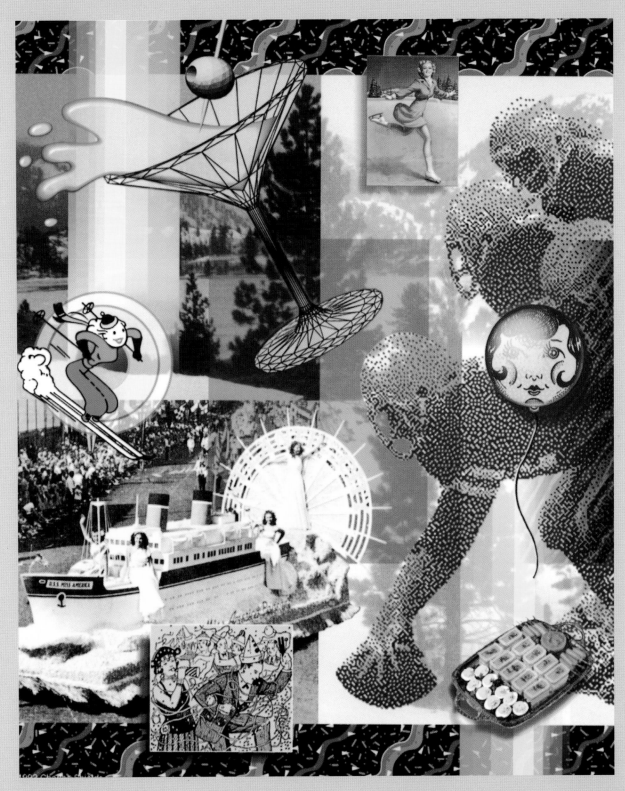

DESIGN FIRM	SHIELDS DESIGN
ART DIRECTOR	CHARLES SHIELDS
DESIGNER	CHARLES SHIELDS
CLIENT	DUMONT PRINTING
SOFTWARE	ADOBE PHOTOSHOP
HARDWARE	MAC

THIS IMAGE WAS DONE FOR A CALENDAR.

DESIGN FIRM HA! HAYDEN & ASSOCIATES
ILLUSTRATOR KATIE HAYDEN
CLIENT SELF-PROMOTION
SOFTWARE ADOBE PHOTOSHOP
HARDWARE MAC IICI

DESIGN FIRM HA! HAYDEN & ASSOCIATES
ILLUSTRATOR KATIE HAYDEN
CLIENT SELF-PROMOTION
SOFTWARE ADOBE PHOTOSHOP
HARDWARE MAC IICI

DESIGN FIRM BETH SANTOS DESIGN
ART DIRECTOR BETH SANTOS
DESIGNER BETH SANTOS
CLIENT SELF-PROMOTION
SOFTWARE ADOBE PHOTOSHOP
HARDWARE MAC II

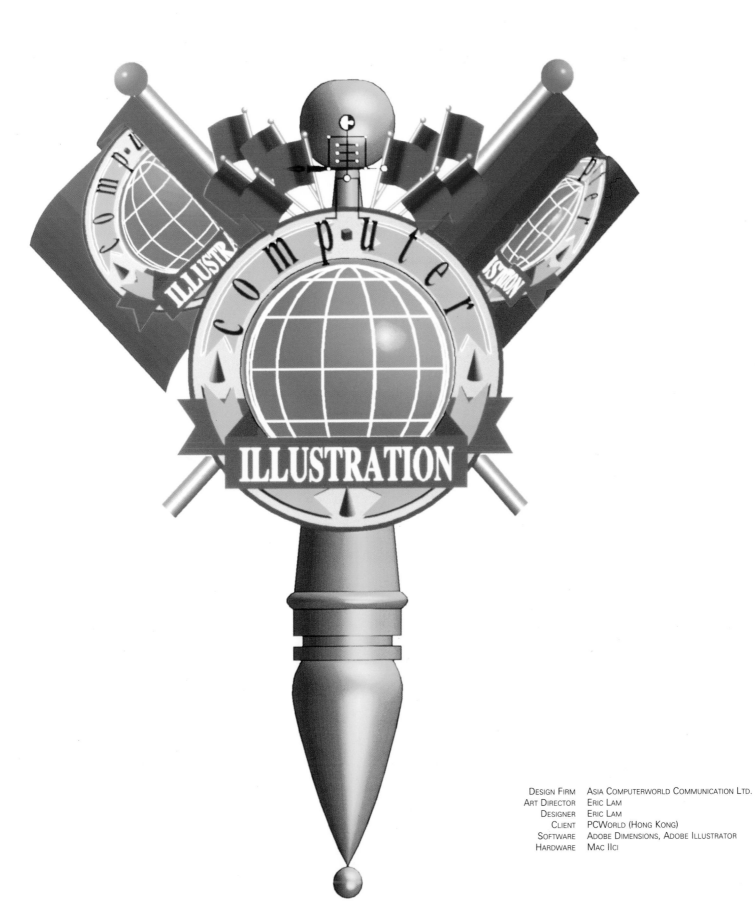

DESIGN FIRM ASIA COMPUTERWORLD COMMUNICATION LTD.
ART DIRECTOR ERIC LAM
DESIGNER ERIC LAM
CLIENT PCWORLD (HONG KONG)
SOFTWARE ADOBE DIMENSIONS, ADOBE ILLUSTRATOR
HARDWARE MAC IICI

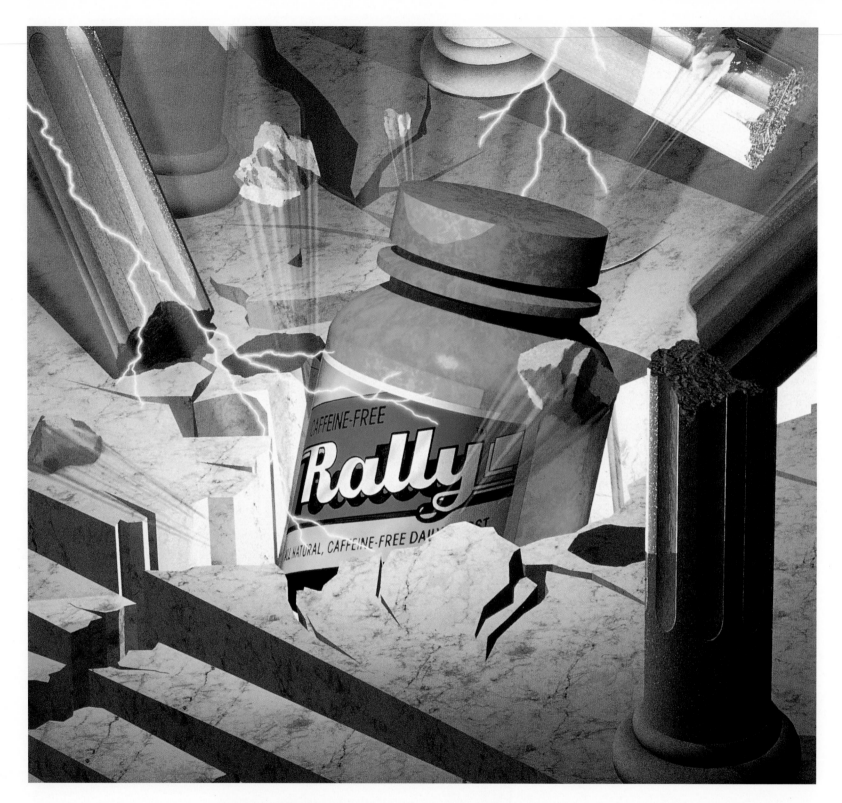

DESIGN FIRM STEVE KELLER PRODUCTIONS
ART DIRECTOR STEVE KELLER
DESIGNER STEVE KELLER
CLIENT PAONIA ENTERPRISES
SOFTWARE PROPRIETARY
HARDWARE PROPRIETARY

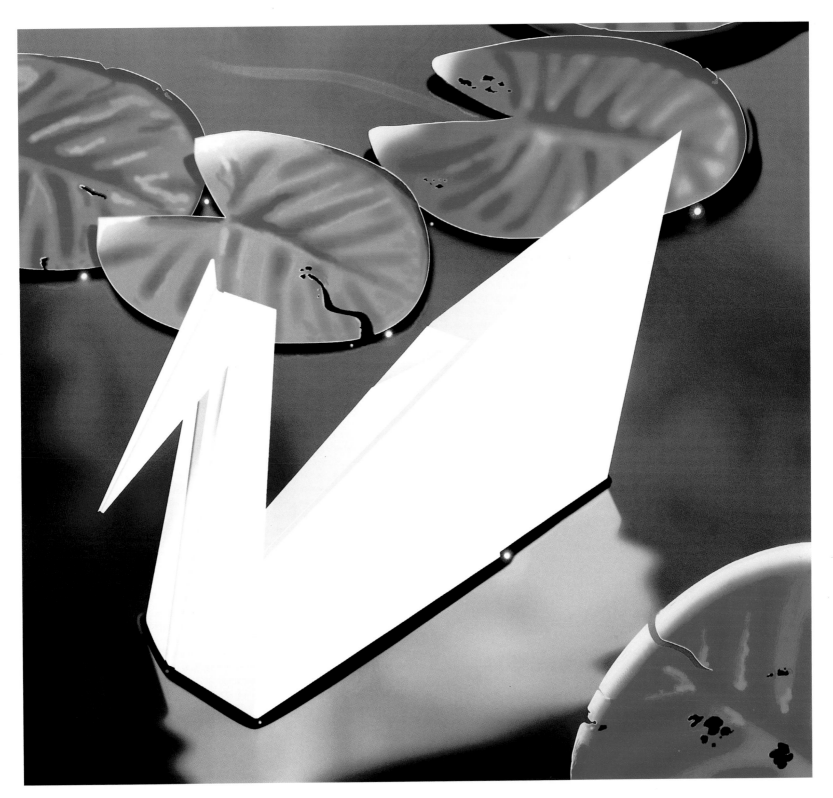

DESIGN FIRM AXELSSON & CO.
ART DIRECTOR ROBERT KIRTLEY
DESIGNER PHILIP NICHOLSON
CLIENT TRYCKMEDIA
SOFTWARE ADOBE ILLUSTRATOR, ADOBE PHOTOSHOP
HARDWARE MAC QUADRA 950

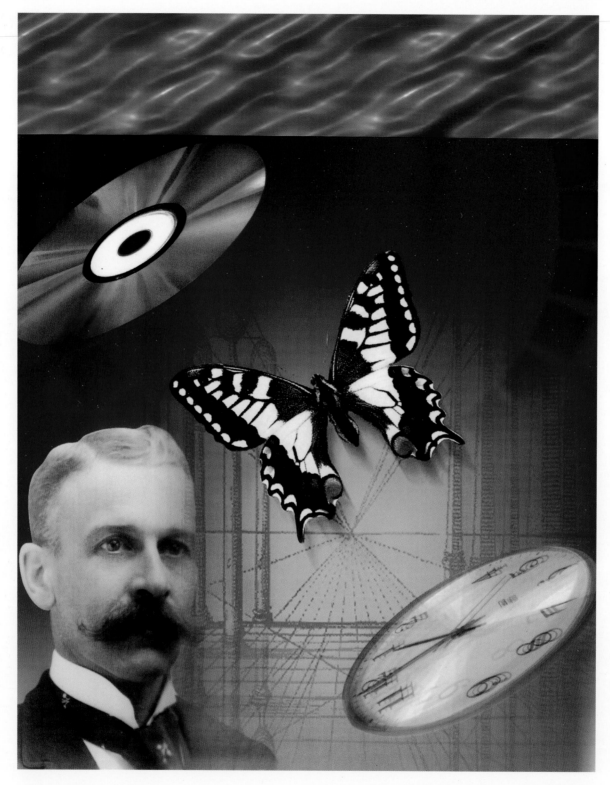

DESIGN FIRM ANDROMEDA SOFTWARE
ART DIRECTOR MARC YANKUS
DESIGNER MARC YANKUS
CLIENT SELF-PROMOTION
SOFTWARE ADOBE PHOTOSHOP
HARDWARE MAC QUADRA 950

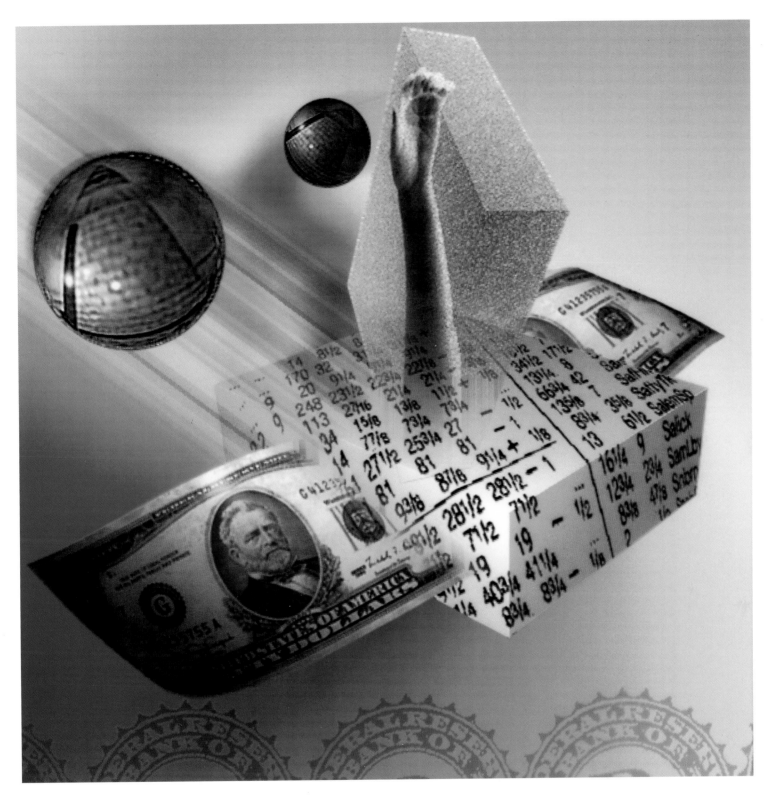

ILLUSTRATOR MARC YANKUS
SOFTWARE ADOBE PHOTOSHOP
HARDWARE MAC QUADRA 950

SIBYL'S FEAR

DESIGNER DOROTHY SIMPSON KRAUSE
SOFTWARE ADOBE PHOTOSHOP, FRACTAL DESIGN PAINTER, COLORSTUDIO
HARDWARE MAC QUADRA 700

WASTELAND

DESIGNER DOROTHY SIMPSON KRAUSE
SOFTWARE ADOBE PHOTOSHOP, FRACTAL DESIGN PAINTER, COLORSTUDIO
HARDWARE MAC QUADRA 700

CHILD OF NUBIA

DESIGNER DOROTHY SIMPSON KRAUSE
SOFTWARE ADOBE PHOTOSHOP, FRACTAL DESIGN PAINTER, COLORSTUDIO
HARDWARE MAC QUADRA 700

JEANNE D'ARC

DESIGNER DOROTHY SIMPSON KRAUSE
SOFTWARE ADOBE PHOTOSHOP, FRACTAL DESIGN PAINTER, COLORSTUDIO
HARDWARE MAC QUADRA 700

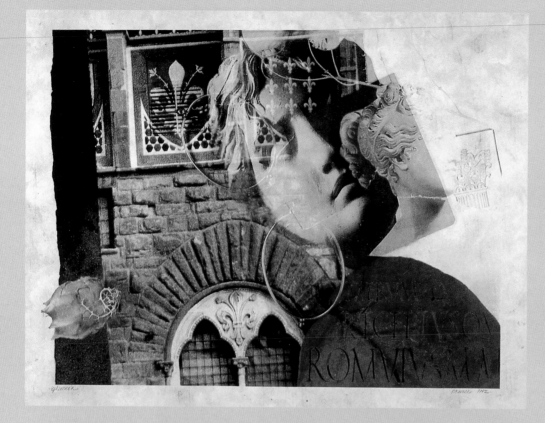

EPHEMERA

DESIGNER DOROTHY SIMPSON KRAUSE
SOFTWARE ADOBE PHOTOSHOP, FRACTAL DESIGN PAINTER, COLORSTUDIO
HARDWARE MAC QUADRA 700

ANATOMY LESSON

DESIGNER DOROTHY SIMPSON KRAUSE
SOFTWARE ADOBE PHOTOSHOP, FRACTAL DESIGN
 PAINTER AND COLORSTUDIO
HARDWARE MAC QUADRA 700

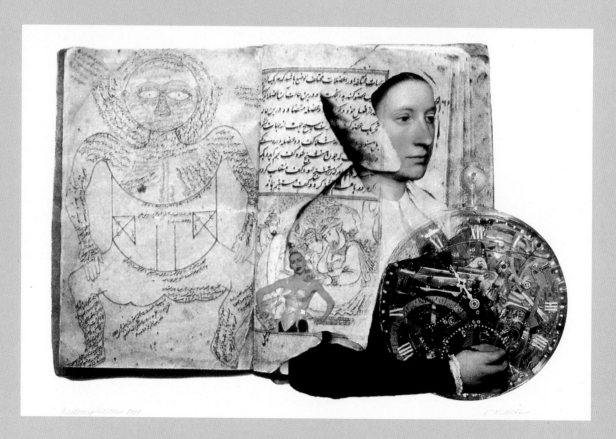

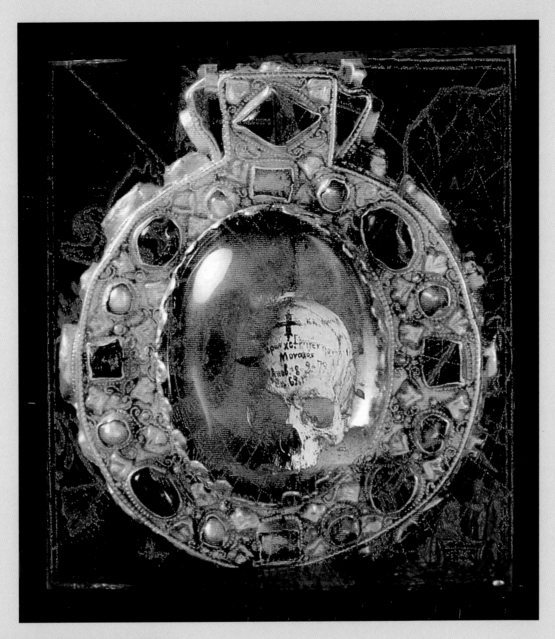

TALISMAN

DESIGNER DOROTHY SIMPSON KRAUSE
SOFTWARE ADOBE PHOTOSHOP, FRACTAL DESIGN PAINTER, COLORSTUDIO
HARDWARE MAC QUADRA 700

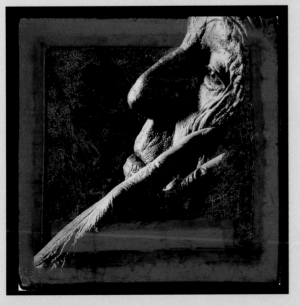

PAST LOVES

DESIGNER DOROTHY SIMPSON KRAUSE
SOFTWARE ADOBE PHOTOSHOP, FRACTAL DESIGN PAINTER, COLORSTUDIO
HARDWARE MAC QUADRA 700

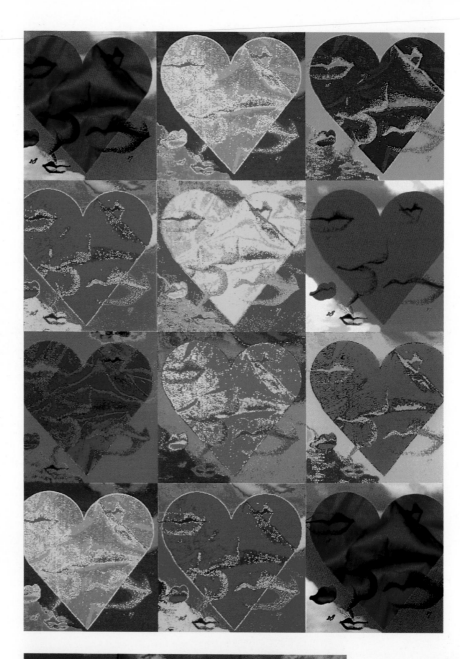

ILLUSTRATOR ROBIN LIPNER
DESIGNER ROBIN LIPNER
CLIENT SELF-PROMOTION
SOFTWARE ADOBE PHOTOSHOP
HARDWARE MAC CENTRIS 650,
 U-MAX SCANNER

ILLUSTRATOR ROBIN LIPNER
DESIGNER ROBIN LIPNER
CLIENT SELF-PROMOTION
SOFTWARE ADOBE PHOTOSHOP
HARDWARE MAC IICI

THIS IS ANDY WARHOL'S VALENTINE.

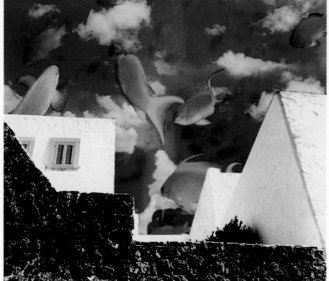

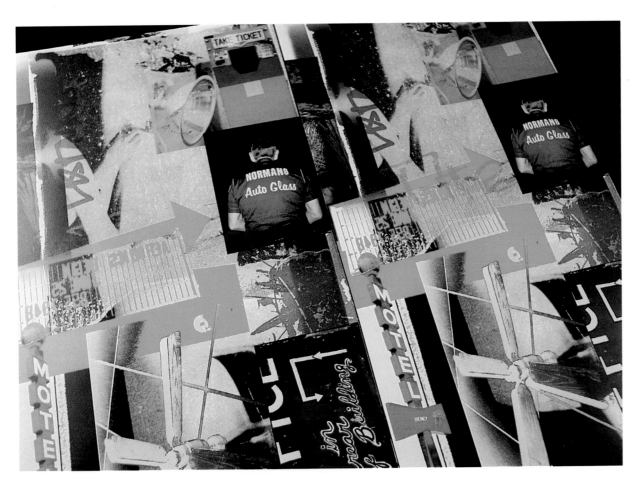

DESIGN FIRM SCHMELTZ AND WARREN
ART DIRECTOR CRIT WARREN
DESIGNER CRIT WARREN
CLIENT AIGA CINCINNATI
SOFTWARE ADOBE PHOTOSHOP, QUARKXPRESS
HARDWARE MAC IIFX, BARNEYSCAN 3515

THIS IS THE FIRST OF FOUR VERTICAL BANDS IN A GROUP EFFORT OF FOUR
DESIGNERS, EACH CREATING ONE-QUARTER OF A FINAL POSTER USED TO
ILLUSTRATE ELECTRONIC DESIGN AND PRODUCTION. THIS PANEL'S FOCUS:
"WHERE IDEAS COME FROM."

TOOLS

DESIGNER CYNTHIA SATLOFF
SOFTWARE ADOBE PHOTOSHOP, FRACTAL DESIGN PAINTER
HARDWARE MAC QUADRA 950

AIRBRUSHING WAS USED TO CREATE PAPER TEXTURES.

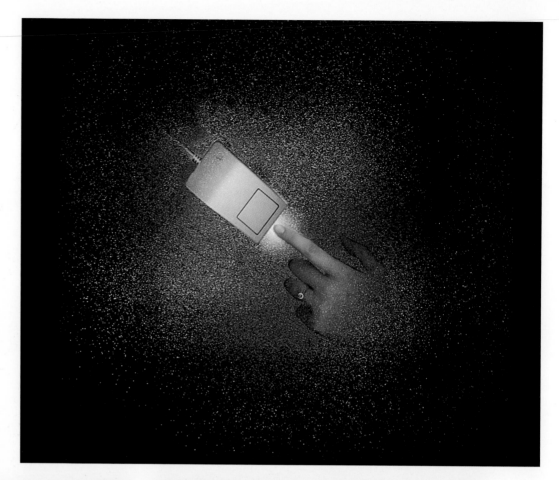

INTRODUCTION TO THE COMPUTER

COMPUTER ILLUSTRATOR NICOLE CRAMERI
SOFTWARE ADOBE PHOTOSHOP

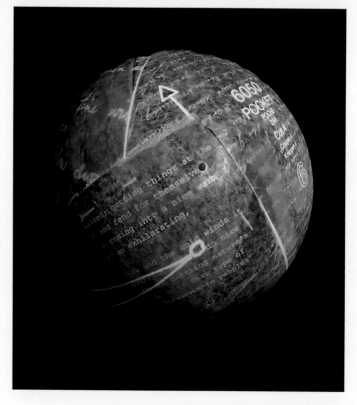

INTRODUCTION TO THE DARKROOM

COMPUTER ILLUSTRATOR NICOLE CRAMERI
SOFTWARE ADOBE PHOTOSHOP

THE PATTERNS IN WHICH WE THINK

COMPUTER ILLUSTRATOR NICOLE CRAMERI
SOFTWARE ADOBE PHOTOSHOP

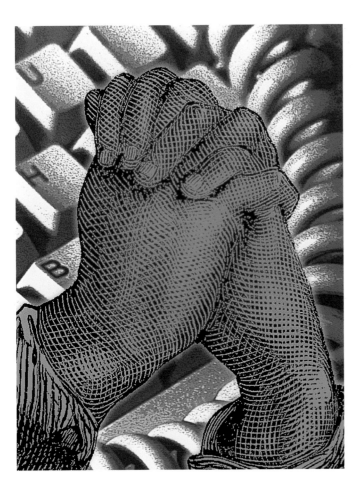

DESIGNER JACQUELINE COMSTOCK
SOFTWARE ADOBE PHOTOSHOP
HARDWARE MAC IIFX

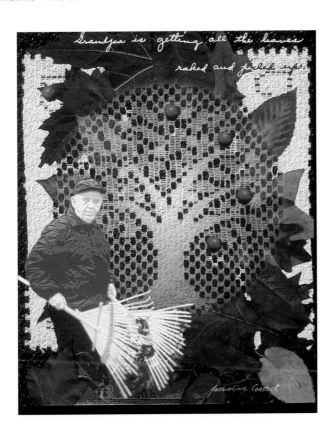

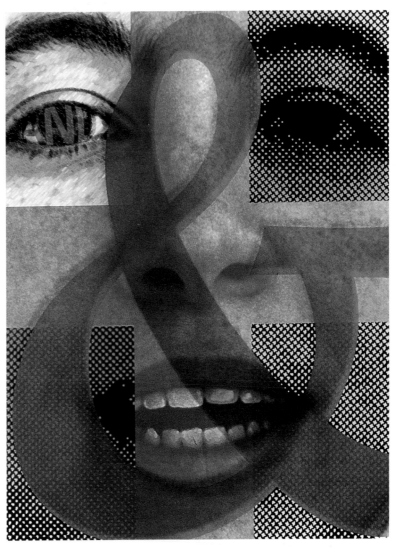

DESIGNER JACQUELINE COMSTOCK
SOFTWARE ADOBE PHOTOSHOP
HARDWARE MAC IICX

DESIGNER JACQUELINE COMSTOCK
SOFTWARE FRACTAL DESIGN PAINTER, ALDUS GALLERY EFFECTS, ADOBE PHOTOSHOP
HARDWARE MAC IICX

F-3323

DESIGN FIRM T2 PRODUCTIONS
ART DIRECTOR KIT MONROE PRAVDA
DESIGNER KIT MONROE PRAVDA
SOFTWARE ADOBE PHOTOSHOP,
KAI'S POWER TOOLS
HARDWARE MAC IICI

FL-3310

DESIGN FIRM T2 PRODUCTIONS
ART DIRECTOR KIT MONROE PRAVDA
DESIGNER KIT MONROE PRAVDA
SOFTWARE ADOBE PHOTOSHOP,
KAI'S POWER TOOLS
HARDWARE MAC IICI

DESIGN FIRM AXELSSON & CO.
ART DIRECTOR ROBERT KIRTLEY
DESIGNER PHILIP NICHOLSON
CLIENT TRYCKMEDIA
SOFTWARE ADOBE ILLUSTRATOR, ADOBE PHOTOSHOP
HARDWARE MAC QUADRA 950

BATHTUB MADONNA AND BEAR
DESIGN FIRM SALZMAN DESIGNS
DESIGNER RICK SALZMAN
CLIENT SELF-PROMOTION
SOFTWARE ADOBE PHOTOSHOP,
FRACTAL DESIGN PAINTER
HARDWARE MAC IIFX

STILL LIFE WITH BLUE LAMP
DESIGN FIRM SALZMAN DESIGNS
DESIGNER RICK SALZMAN
CLIENT SELF-PROMOTION
SOFTWARE FRACTAL DESIGN PAINTER
HARDWARE MAC IIFX

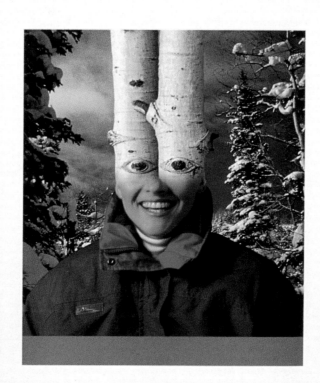

DESIGN FIRM THE WELLER INSTITUTE FOR THE CURE OF DESIGN, INC.
ART DIRECTOR DON WELLER
DESIGNER DON WELLER
CLIENT THE DESIGN CONFERENCE THAT JUST HAPPENS TO BE IN PARK CITY 1993
SOFTWARE QUARKXPRESS, ADOBE PHOTOSHOP
HARDWARE MAC QUADRA

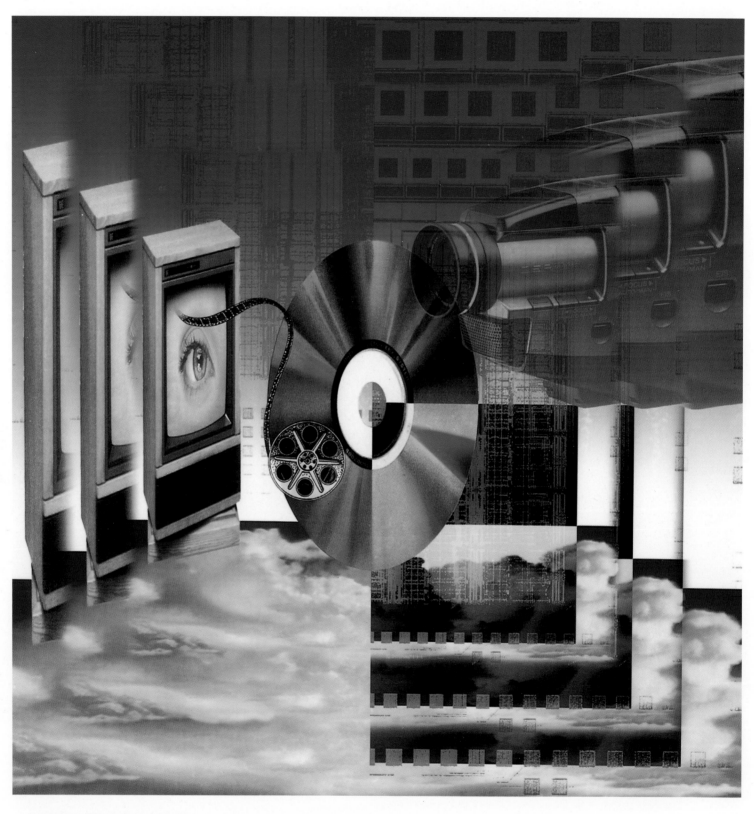

DESIGN FIRM POPULAR SCIENCE MAGAZINE
ART DIRECTOR TOM WHITE
ILLUSTRATOR MARC YANKUS
SOFTWARE ADOBE PHOTOSHOP
HARDWARE MAC QUADRA 950

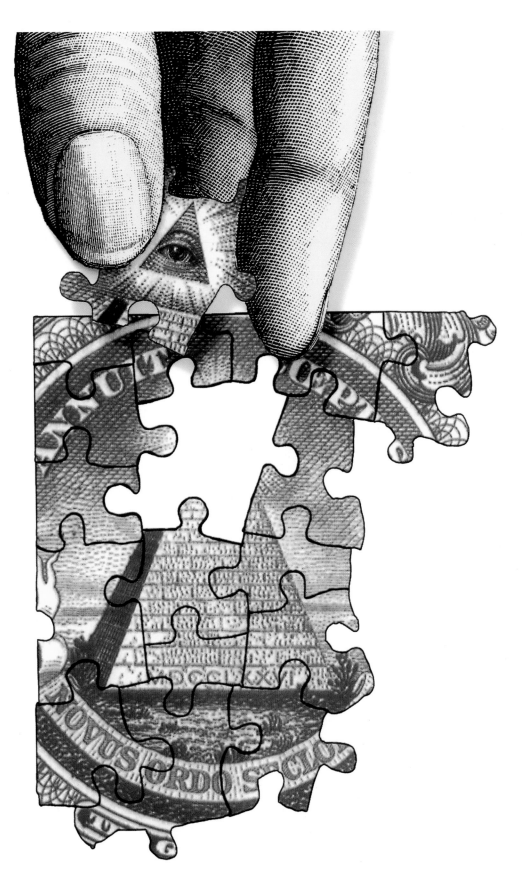

DESIGN FIRM CLARK KELLOGG DESIGN
ART DIRECTOR CLARK KELLOGG
DESIGNER MARC YANKUS
CLIENT BANKERS TRUST
SOFTWARE ADOBE PHOTOSHOP
HARDWARE MAC QUADRA 950

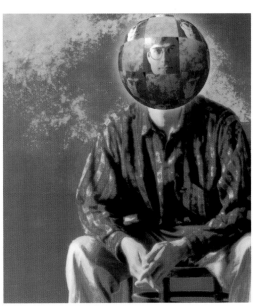

DESIGN FIRM TIME MAGAZINE
ART DIRECTOR BILL POWERS
ILLUSTRATOR MARC YANKUS
SOFTWARE ADOBE PHOTOSHOP
HARDWARE MAC QUADRA 950

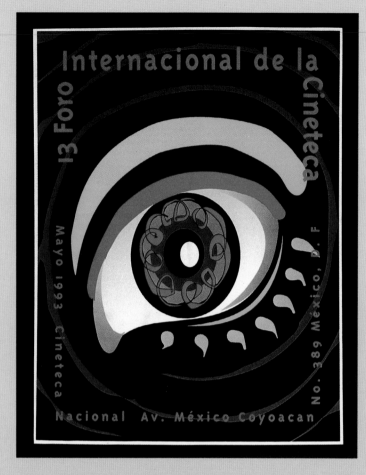

DESIGN FIRM BURGEFF CO.
ART DIRECTOR PATRICK BURGEFF
DESIGNER PATRICK BURGEFF
CLIENT FILM FESTIVAL CONTEST CINETECA
SOFTWARE ALDUS FREEHAND
HARDWARE MAC IICI

DESIGN FIRM DESIGN ART, INC.
ART DIRECTOR NORMAN MOORE
DESIGNER NORMAN MOORE
CLIENT THE MOODY BLUES
SOFTWARE ALDUS FREEHAND, QUARKXPRESS
HARDWARE MAC IIFX

DESIGN FIRM BURGEFF CO.
ART DIRECTOR PATRICK BURGEFF
DESIGNER PATRICK BURGEFF
CLIENT EL GLOBO
SOFTWARE ALDUS FREEHAND
HARDWARE MAC IICI

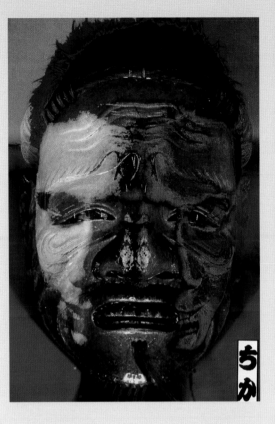

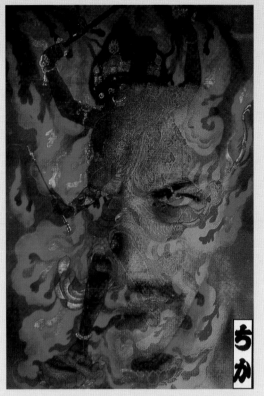

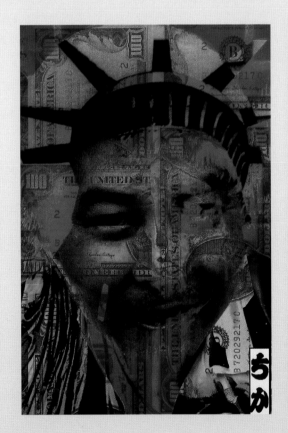

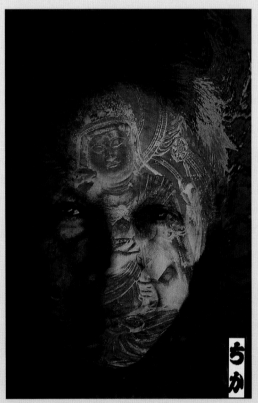

DESIGNER CHIKA IIJIMA
SOFTWARE ADOBE PHOTOSHOP
HARDWARE MAC

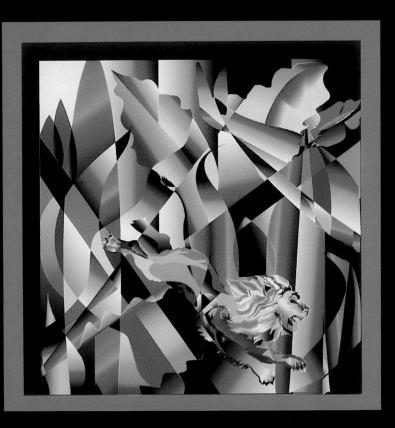

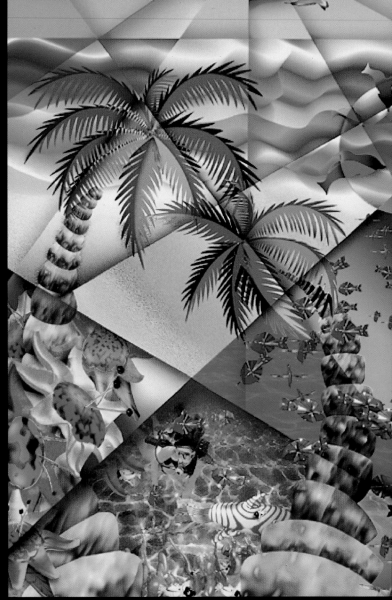

DESIGN FIRM GROSSMAN ILLUSTRATION
ART DIRECTOR WENDY GROSSMAN
DESIGNER WENDY GROSSMAN
CLIENT SELF-PROMOTION
SOFTWARE ADOBE ILLUSTRATOR, ADOBE PHOTOSHOP, RAY DREAM DESIGNER
HARDWARE MAC QUADRA 700

DESIGN FIRM GROSSMAN ILLUSTRATION
ART DIRECTOR WENDY GROSSMAN
DESIGNER WENDY GROSSMAN
CLIENT SELF-PROMOTION
SOFTWARE ADOBE ILLUSTRATOR, ADOBE PHOTOSHOP, RAY DREAM DESIGNER
HARDWARE MAC QUADRA 700

SUNFLOWERS
DESIGN FIRM PSEUDAXIS GRAPHICS
DESIGNER MICHELLE NETTLETON
SOFTWARE DELUXE PAINT IV
HARDWARE AMIGA 4000

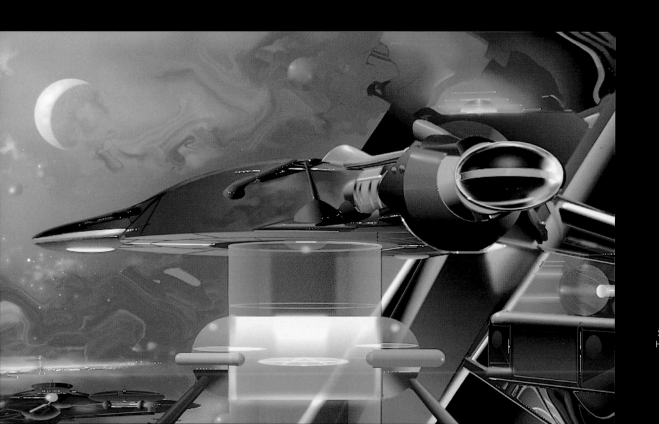

HELIX 1-10-93
DESIGNER ANTONIO ANGULO
CLIENT SELF-PROMOTION
SOFTWARE ADOBE PHOTOSHOP
HARDWARE MAC CENTRIS 650

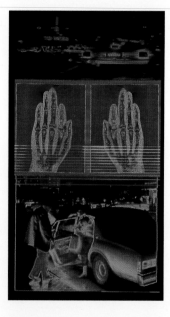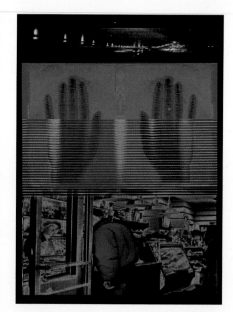

DESIGNER DIANE FENSTER, COMPUTER ART & DESIGN
SOFTWARE ADOBE PHOTOSHOP
HARDWARE MACFX, NEXUS FX ACCELERATOR

THESE ARE SELECTIONS FROM "THE POINT OF EMERGENCE" SERIES.

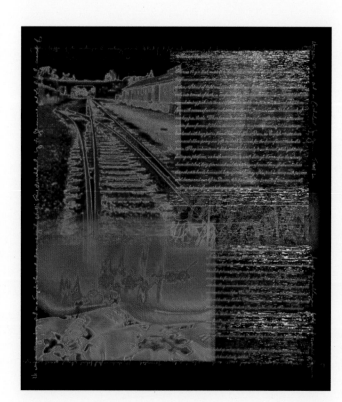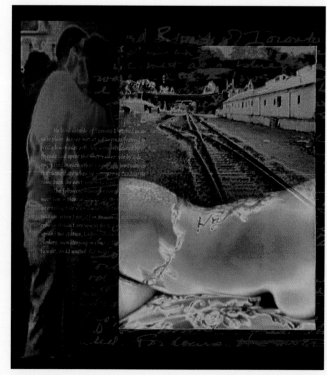

DESIGNER DIANE FENSTER
SOFTWARE ADOBE PHOTOSHOP
HARDWARE MACFX, NEXUS FX ACCELERATOR

THESE ARE SIX IMAGES FROM THE "RITUAL OF ABANDONMENT" SERIES.

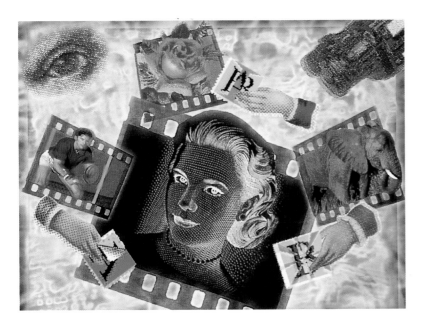

ART DIRECTOR SYLVIA BENVENUTTI
DESIGNER DIANE FENSTER
CLIENT MACWORLD MAGAZINE
SOFTWARE ADOBE PHOTOSHOP
HARDWARE MACFX, NEXUS FX ACCELERATOR

THIS IS A PREMIERE 3.0 EDITORIAL ILLUSTRATION.

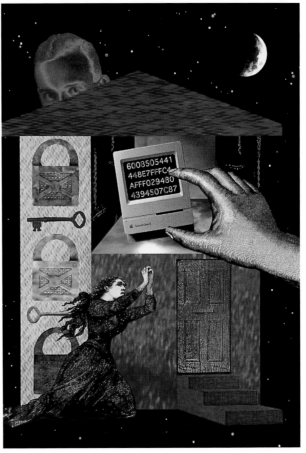

DATA GUARDIANS
ART DIRECTOR SYLVIA BENVENUTTI
DESIGNER DIANE FENSTER
CLIENT MACWORLD MAGAZINE
SOFTWARE ADOBE PHOTOSHOP
HARDWARE MAC IIFX, NEXUS FX ACCELERATOR

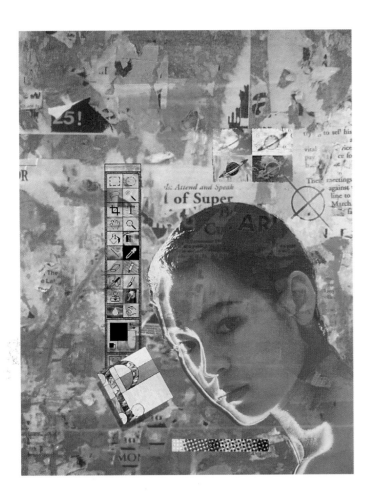

DESIGN FIRM KAVISH & KAVISH
ART DIRECTOR MICHAEL KAVISH
DESIGNER DIANE FENSTER
CLIENT IDG BOOKS
SOFTWARE ADOBE PHOTOSHOP
HARDWARE MAC IIFX, NEXUS FX ACCELERATOR

THIS IS A BIBLE COVER ILLUSTRATION.

DIGITAL ILLUSTRATOR/
PHOTOGRAPHER ANDREW J. HATHAWAY
SOFTWARE ADOBE PHOTOSHOP
HARDWARE MAC IIFX, WACOM TABLET, KODAK PHOTO CD

DIGITAL ILLUSTRATOR/
PHOTOGRAPHER ANDREW J. HATHAWAY
SOFTWARE WACOM TABLET, ADOBE PHOTOSHOP, FRACTAL DESIGN PAINTER
HARDWARE MAC IIFX, KODAK PHOTO CD

THIS IS PART OF AN ONGOING SERIES OF IMAGES BY ROB BAYNE (COLLABORATOR).

MUGSY

DIGITAL ILLUSTRATOR/
PHOTOGRAPHER ANDREW J. HATHAWAY
SOFTWARE XAOS PAINT ALCHEMY, ADOBE PHOTOSHOP
HARDWARE MAC IIFX, WACOM TABLET, KODAK PHOTO CD

DIGITAL ILLUSTRATOR/
PHOTOGRAPHER ANDREW J. HATHAWAY
SOFTWARE ADOBE PHOTOSHOP, FRACTAL DESIGN PAINTER
HARDWARE MAC IIFX, WACOM TABLET, KODAK PHOTO CD

DOUG

DIGITAL ILLUSTRATOR/
PHOTOGRAPHER ANDREW J. HATHAWAY
SOFTWARE ADOBE PHOTOSHOP, FRACTAL DESIGN PAINTER
HARDWARE MAC IIFX, WACOM TABLET, KODAK PHOTO CD

DESIGNER PHILIP NICHOLSON
CLIENT HOGIA DATA
SOFTWARE ADOBE ILLUSTRATOR, ADOBE PHOTOSHOP, FRACTAL DESIGN PAINTER
HARDWARE MAC QUADRA 950

PSYCHEDELIC RELIC

DESIGNER CHRISTOPHER PALLOTTA
SOFTWARE ADOBE PHOTOSHOP, FRACTAL DESIGN PAINTER
HARDWARE MAC

COMPUTER INTERFACE DESIGN

COMPUTER ILLUSTRATOR NICOLE CRAMERI
DESIGNER COMPUTER ILLUSTRATION
SOFTWARE ADOBE PHOTOSHOP

Packaging

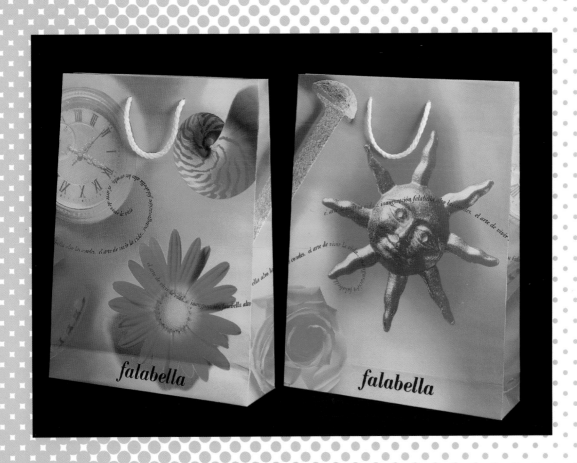

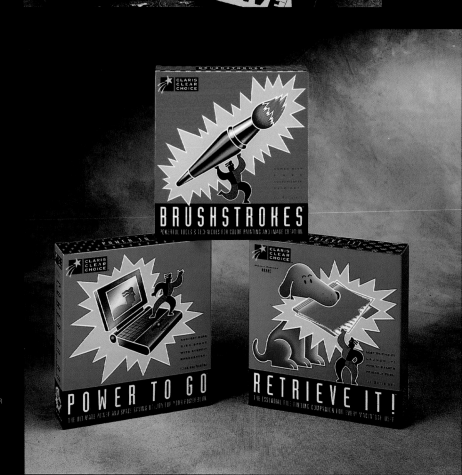

DESIGN FIRM	EARL GEE DESIGN
ART DIRECTOR	EARL GEE
ILLUSTRATOR	EARL GEE, DAVID BOTTOMS
DESIGNER	EARL GEE, FANI CHUNG
CLIENT	PENSOFT CORPORATION
SOFTWARE	QUARKXPRESS, ADOBE ILLUSTRATOR, ADOBE PHOTOSHOP
HARDWARE	MAC IICI

DESIGN FIRM	EARL GEE DESIGN
ART DIRECTOR	EARL GEE
DESIGNER	EARL GEE, FANI CHUNG
ILLUSTRATOR	EARL GEE, DAVID BOTTOMS
CLIENT	CLARIS CLEAR CHOICE
SOFTWARE	QUARKXPRESS, ADOBE ILLUSTRATOR
HARDWARE	MAC IICI

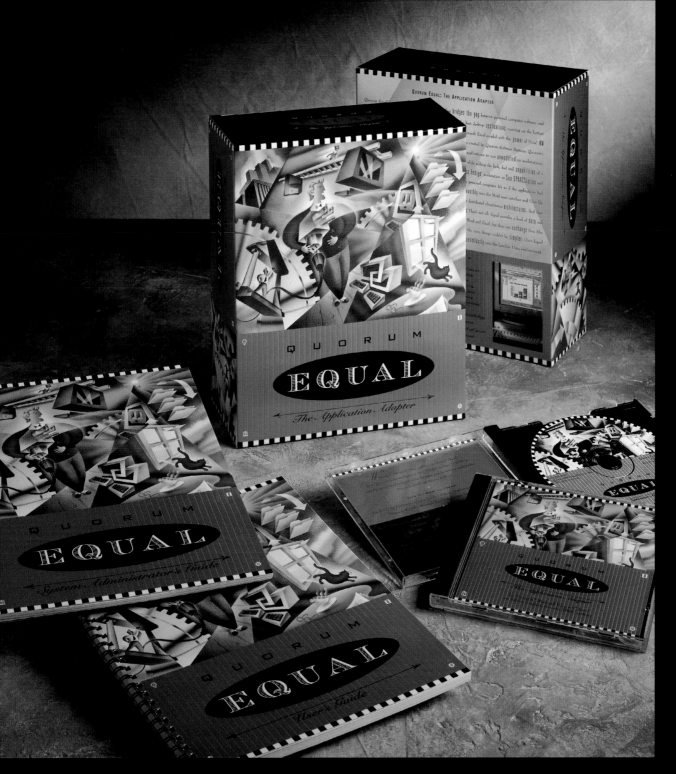

DESIGN FIRM EARL GEE DESIGN
ART DIRECTOR EARL GEE
DESIGNER EARL GEE, FANI CHUNG
ILLUSTRATOR JOHN MATTOS
CLIENT QUORUM SOFTWARE SYSTEMS, IN
SOFTWARE QUARKXPRESS, ADOBE ILLUSTRAT
HARDWARE MAC IICI

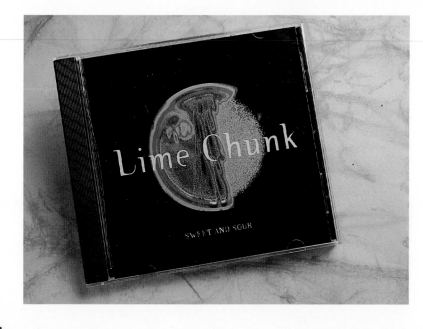

DESIGN FIRM SEGURA INC.
ART DIRECTOR CARLOS SEGURA
DESIGNER CARLOS SEGURA
CLIENT T-26/LIME CHUNK
SOFTWARE ADOBE PHOTOSHOP, ADOBE
 ILLUSTRATOR, ADOBE STREAMLINE,
 ALTSYS FONTOGRAPHER
HARDWARE MAC QUADRA 800

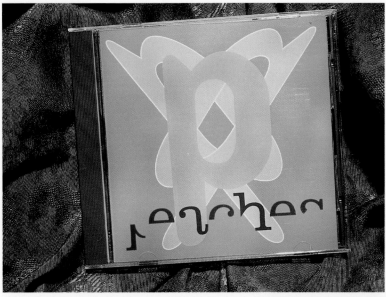

DESIGN FIRM SEGURA INC.
ART DIRECTOR CARLOS SEGURA
DESIGNER CARLOS SEGURA
CLIENT PEACHES
SOFTWARE ADOBE PHOTOSHOP, QUARKXPRESS, ADOBE ILLUSTRATOR, ADOBE
 STREAMLINE, ALTSYS FONTOGRAPHER
HARDWARE MAC QUADRA 800

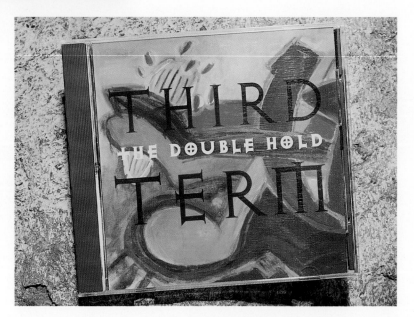

DESIGN FIRM SEGURA INC.
ART DIRECTOR CARLOS SEGURA
DESIGNER CARLOS SEGURA
CLIENT THIRD TERM
SOFTWARE QUARKXPRESS, ADOBE PHOTOSHOP,
 ADOBE ILLUSTRATOR, ADOBE
 STREAMLINE
HARDWARE MAC QUADRA 800

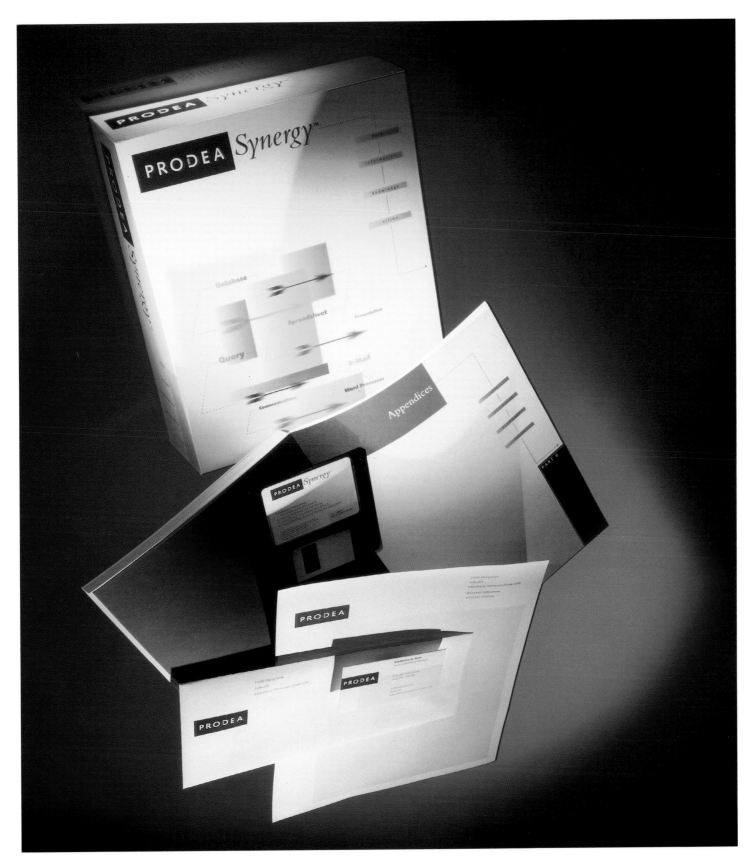

DESIGN FIRM LARSEN DESIGN OFFICE, INC.
ART DIRECTOR TIM LARSEN
DESIGNER NANCY WHITTLESEY
CLIENT PRODEA
SOFTWARE QUARKXPRESS, ADOBE PHOTOSHOP
HARDWARE MAC QUADRA 700, FIERY 200 WITH CANON COPIER 550

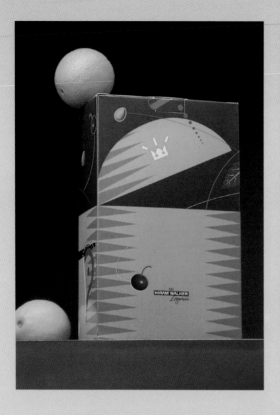 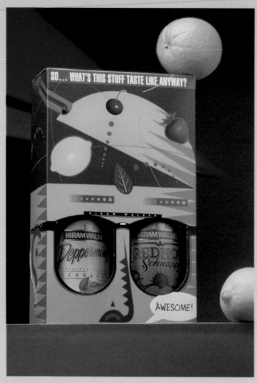

AGENCY BEELINE GROUP
DESIGN FIRM THARP (AND DRUMMOND) DID IT
ART DIRECTOR RICK THARP, CHARLES DRUMMOND
DESIGNER RICK THARP
CLIENT HIREM WALKER LIQUEURS
SOFTWARE ADOBE ILLUSTRATOR, ADOBE DIMENSIONS
HARDWARE MAC

DESIGN FIRM RILEY DESIGN ASSOCIATES
ART DIRECTOR DANIEL RILEY
DESIGNER DANIEL RILEY
CLIENT FULL MOON FLAT
SOFTWARE ALDUS PAGEMAKER
HARDWARE MAC II

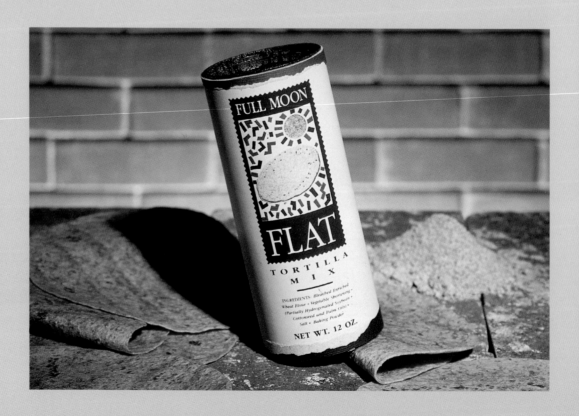

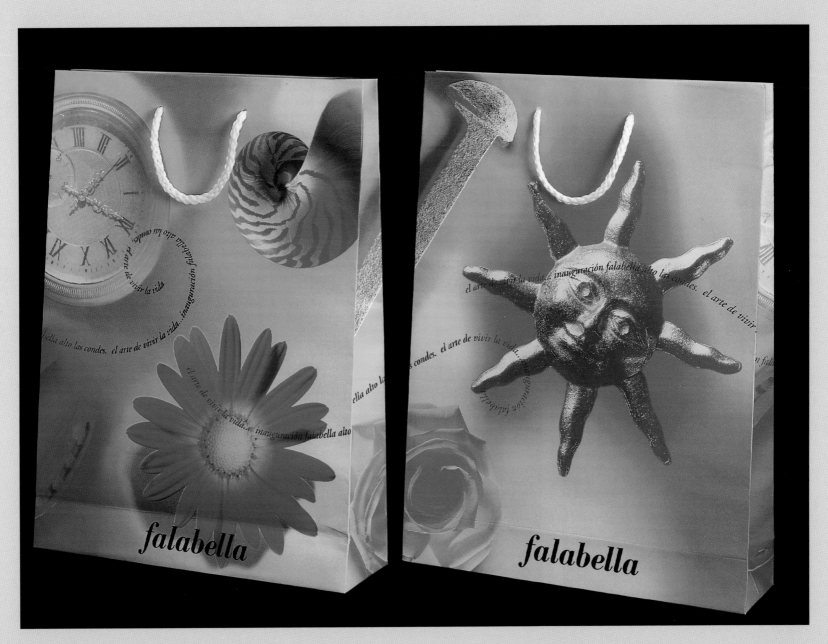

Design Firm	Art & Function
Art Director	Suzanne De Loughry
Illustrator	Carolina De La Paz, Studio Digital
Photographer	Jorge Brantmayer
Client	Falabella Department Stores
Software	Adobe Photoshop, Aldus FreeHand
Hardware	Mac Quadra 800

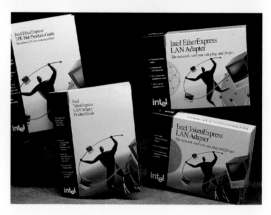

DESIGN FIRM HORNALL ANDERSON
 DESIGN WORKS
ART DIRECTOR JACK ANDERSON, JULIA LAPINE
DESIGNER JACK ANDERSON, JULIA LAPINE,
 LIAN NG, HEIDI HATLESTAD, BRUCE
 BRANSON-MEYER, DAVID BATES,
 LESLIE MACINNES
CLIENT INTEL CORPORATION
SOFTWARE ALDUS PAGEMAKER, ALDUS
 FREEHAND, ADOBE PHOTOSHOP
HARDWARE MAC QUADRA 800,
 SUPER MAC THUNDAR II LIGHT

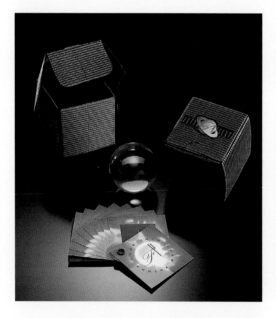

DESIGN FIRM VAUGHN WEDEEN CREATIVE
ART DIRECTOR STEVE WEDEEN
DESIGNER STEVE WEDEEN
COMPUTER PRODUCTION CHIP WYLY
CLIENT U.S. WEST COMMUNICATIONS
SOFTWARE ADOBE PHOTOSHOP, ALDUS FREEHAND, QUARKXPRESS
HARDWARE MAC IICX WITH RADIUS ROCKET

DESIGN FIRM PLANETARY DISSEMINATION ORG.
ART DIRECTOR HELEN PINDER
DESIGNER KALLEHEIKKI KANNISTO
CLIENT IN-HOUSE
SOFTWARE ADOBE PHOTOSHOP, ADOBE ILLUSTRATOR
HARDWARE MAC QUADRA 800

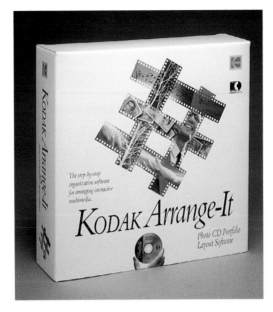

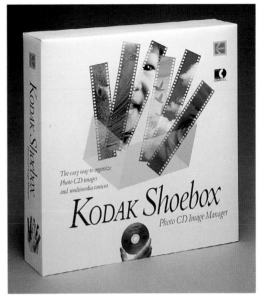

DESIGN FIRM	NEUMEIER DESIGN TEAM
ART DIRECTOR	MARTY NEUMEIER
DESIGNER	CHRIS CHU, ERIC TODD
CLIENT	EASTMAN KODAK
SOFTWARE	QUARKXPRESS, ADOBE PHOTOSHOP, ALDUS FREEHAND
HARDWARE	MAC QUADRA 950

DESIGN FIRM	NEUMEIER DESIGN TEAM
ART DIRECTOR	MARTY NEUMEIER
DESIGNER	NANCY BERNARD, ERIC TODD
CLIENT	EASTMAN KODAK
SOFTWARE	QUARKXPRESS, ADOBE PHOTOSHOP, ALDUS FREEHAND
HARDWARE	MAC QUADRA 950

DESIGN FIRM	NEUMEIER DESIGN TEAM
ART DIRECTOR	MARTY NEUMEIER
DESIGNER	CHRIS CHU, ERIC TODD
CLIENT	EASTMAN KODAK
SOFTWARE	QUARKXPRESS, ADOBE PHOTOSHOP, ALDUS FREEHAND
HARDWARE	MAC QUADRA 950

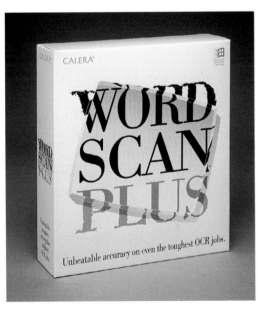

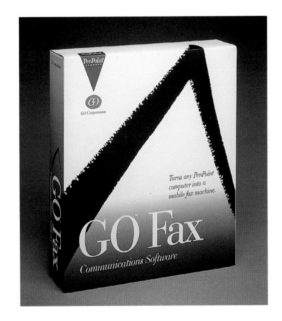

DESIGN FIRM	NEUMEIER DESIGN TEAM
ART DIRECTOR	MARTY NEUMEIER
DESIGNER	CHRIS CHU, ERIC TODD
CLIENT	CALERA
SOFTWARE	QUARKXPRESS, ADOBE PHOTOSHOP, ALDUS FREEHAND
HARDWARE	MAC QUADRA 950

DESIGN FIRM	NEUMEIER DESIGN TEAM
ART DIRECTOR	MARTY NEUMEIER
DESIGNER	CHRIS CHU, ERIC TODD
CLIENT	GO CORP.
SOFTWARE	QUARKXPRESS, ADOBE PHOTOSHOP, ALDUS FREEHAND
HARDWARE	MAC QUADRA 950

DESIGN FIRM	NEUMEIER DESIGN TEAM
ART DIRECTOR	MARTY NEUMEIER
DESIGNER	CHRIS CHU, ERIC TODD
CLIENT	GO CORP.
SOFTWARE	QUARKXPRESS, ADOBE PHOTOSHOP, ALDUS FREEHAND
HARDWARE	MAC QUADRA 950

DESIGN FIRM RILEY DESIGN ASSOCIATES
ART DIRECTOR DANIEL RILEY
DESIGNER DANIEL RILEY
CLIENT BLACKSMITH WORKS
SOFTWARE ALDUS FREEHAND, ALDUS PAGEMAKER
HARDWARE MAC II

DESIGN FIRM WALCOTT-AYERS GROUP
ART DIRECTOR JIM WALCOTT-AYERS
DESIGNER LIZ POLLINA, JIM WALCOTT-AYERS
CLIENT CHRISTMAS SELF-PROMOTION
SOFTWARE ADOBE ILLUSTRATOR, ADOBE PHOTOSHOP
HARDWARE MAC IICI

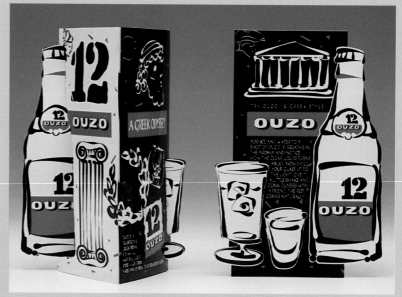

DESIGN FIRM STRADA COMMUNICATIONS LTD.
ART DIRECTOR NEWELL THORNTON, SALLY LENOX
ILLUSTRATOR CANDACE LOURDES
CLIENT GIBLEY'S CANADA
SOFTWARE ALDUS FREEHAND, ADOBE ILLUSTRATOR
HARDWARE MAC CENTRIS 650, WACOM TABLET, IGB EXTERNAL

DESIGN FIRM HORNALL ANDERSON DESIGN WORKS
ART DIRECTOR JOHN HORNALL
DESIGNER JOHN HORNALL, SCOTT EGGERS
CLIENT INTEL CORPORATION
SOFTWARE ALDUS FREEHAND
HARDWARE MAC QUADRA 800, SUPER MAC THUNDAR II LIGHT

Corporate Identity

wa·tam·ai

DESIGNER JACQUELINE COMSTOCK
SOFTWARE ALDUS FREEHAND
HARDWARE MAC IICX

DESIGN FIRM STUDIO SEIREENI
ART DIRECTOR ROMANE CAMERON
DESIGNER ROMANE CAMERON
CLIENT FREDERIC AND NICHOLAS MESCHIN
SOFTWARE ALDUS FREEHAND
HARDWARE MAC IICI

DESIGN FIRM M. RENNER DESIGN
ART DIRECTOR MICHAEL RENNER
DESIGNER MICHAEL RENNER
CLIENT STUDIO PIGNATELLI/USTER,
 SWITZERLAND
SOFTWARE ADOBE ILLUSTRATOR
HARDWARE MAC II, QUADRA 950
 STUDIO PIGNATELLI IS A STUDIO FOR
 3-D DESIGN.

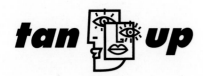

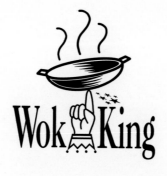

DESIGN FIRM STUDIO SEIREENI
ART DIRECTOR ROMANE CAMERON
DESIGNER ROMANE CAMERON
CLIENT DANIEL HAFID
SOFTWARE ALDUS FREEHAND
HARDWARE MAC IICI

DESIGN FIRM WICKY LEE AD/GRAPHIC DESIGN
ART DIRECTOR WICKY LEE
DESIGNER WICKY LEE
CLIENT THE ART INSTITUTE OF PHILADELPHIA
SOFTWARE ALDUS FREEHAND
HARDWARE MAC IICI

DESIGN FIRM M. RENNER DESIGN
ART DIRECTOR MICHAEL RENNER
DESIGNER MICHAEL RENNER
CLIENT ESPRIT SWITZERLAND
SOFTWARE ADOBE ILLUSTRATOR
HARDWARE MAC II, QUADRA 950

DESIGN FIRM	M. RENNER DESIGN
ART DIRECTOR	MICHAEL RENNER
DESIGNER	MICHAEL RENNER
CLIENT	EUROPA-FACHPRESSE-VERLAG/MUNCHEN, GERMANY
SOFTWARE	ADOBE ILLUSTRATOR
HARDWARE	MAC II, QUADRA 950

DESIGN FIRM	HORNALL ANDERSON DESIGN WORKS
ART DIRECTOR	JACK ANDERSON
DESIGNER	JACK ANDERSON, DAVID BATES, CLIFF CHUNG
CLIENT	MICROSOFT CORPORATION
SOFTWARE	ALDUS FREEHAND
HARDWARE	MAC QUADRA 800, SUPER MAC THUNDAR II LIGHT

DESIGN FIRM	HORNALL ANDERSON DESIGN WORKS
ART DIRECTOR	JACK ANDERSON
DESIGNER	JACK ANDERSON, DAVID BATES, CLIFF CHUNG, LEO RAYMUNDO, DENISE WEIR
CLIENT	MISSION RIDGE
SOFTWARE	ALDUS FREEHAND
HARDWARE	MAC QUADRA 800, SUPER MAC THUNDAR II LIGHT

DESIGN FIRM	M. RENNER DESIGN
ART DIRECTOR	MICHAEL RENNER
DESIGNER	MICHAEL RENNER
CLIENT	PREPRESS-CONSULTING, PREPRESS-REPORT/BINNINGEN, SWITZERLAND
SOFTWARE	ADOBE ILLUSTRATOR
HARDWARE	MAC II, QUADRA 950

DESIGN FIRM	HORNALL ANDERSON DESIGN WORKS
ART DIRECTOR	JACK ANDERSON
DESIGNER	JACK ANDERSON, BRIAN O'NEILL
CLIENT	GANG OF SEVEN
SOFTWARE	ALDUS FREEHAND
HARDWARE	MAC QUADRA 800, SUPER MAC THUNDAR II LIGHT

DESIGN FIRM	HORNALL ANDERSON DESIGN WORKS
ART DIRECTOR	JACK ANDERSON
DESIGNER	DAVID BATES, JULIA LAPINE, LIAN NG
CLIENT	INTEL CORPORATION
SOFTWARE	ALDUS FREEHAND, ALDUS PAGEMAKER
HARDWARE	MAC QUADRA 800, SUPER MAC THUNDAR II LIGHT

Design Firm	Jacqueline Smith Design
Art Director	Jacqueline Smith
Designer	Jacqueline Smith
Client	Jacqueline Smith
Software	Aldus FreeHand
Hardware	Mac

Design Firm	Janet Scabrini Design Inc.
Art Director	Janet Scabrini
Designer	Pat Rotondo (Mac Print Version)
Client	Vermont Public Television
Software	Adobe Illustrator, Quantel Paintbox (Video)
Hardware	Mac Quadra 700, Quantel Paintbox (Video)

Design Firm	Rickabaugh Graphics
Art Director	Michael Tennyson Smith
Designer	Michael Tennyson Smith
Client	Columbus Parks and Recreation Department
Software	Aldus FreeHand
Hardware	Mac IIci

Design Firm	Javier Romero Design Group
Art Director	Javier Romero
Designer	Gary St. Clare
Client	New York City Mayor's Office
Software	Adobe Illustrator
Hardware	Mac Quadra

DESIGN FIRM	MIKE SALISBURY COMMUNICATIONS INC.
ART DIRECTOR	MIKE SALISBURY
DESIGNER	MIKE SALISBURY
CLIENT	DIGITAL DOMAIN
SOFTWARE	ADOBE ILLUSTRATOR
HARDWARE	MAC QUADRA 800

DESIGN FIRM	WHITNEY EDWARDS DESIGN
ART DIRECTOR	CHARLENE WHITNEY EDWARDS
DESIGNER	CHARLENE WHITNEY EDWARDS
CLIENT	BIGA FUND
SOFTWARE	ADOBE ILLUSTRATOR
HARDWARE	MAC QUADRA 950

DESIGN FIRM	M. RENNER DESIGN
ART DIRECTOR	MICHAEL RENNER
DESIGNER	MICHAEL RENNER
CLIENT	SWIP HANDELS AG/ZURICH, SWITZERLAND
SOFTWARE	ADOBE ILLUSTRATOR
HARDWARE	MAC II, QUADRA 950

DESIGN FIRM	M. RENNER DESIGN
ART DIRECTOR	MICHAEL RENNER
DESIGNER	MICHAEL RENNER
CLIENT	TEACHERS' UNION/BASEL, SWITZERLAND
SOFTWARE	ADOBE ILLUSTRATOR
HARDWARE	MAC II, QUADRA 950

Broadcast Design

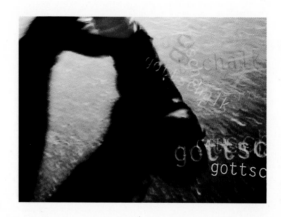

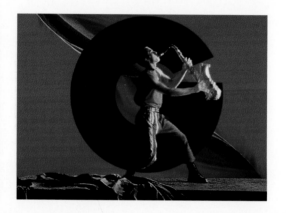

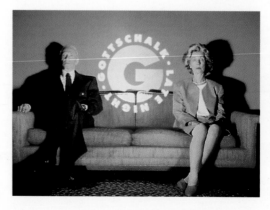
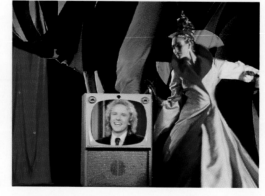

Gottschalk Late Night

Design Firm	Pittard Sullivan Fitzgerald
Art Director	Ed Sullivan
Designer	Suzanne Kiley
3-D Artist	Bill Konersman
Client	RTL, Brot & Spiele
Software	Adobe Illustrator
Hardware	Quantel Paintbox, Quantel Harry

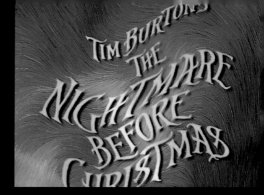

THE NIGHTMARE BEFORE CHRISTMAS

DESIGN FIRM PITTARD SULLIVAN FITZGERALD
ART DIRECTOR JEFF BOORTZ
DESIGNER JEFF BOORTZ
CLIENT WALT DISNEY CO.
SOFTWARE WAVEFRONT, PANDEMONIUM
HARDWARE SILICON GRAPHICS

Roc

DESIGN FIRM	PITTARD SULLIVAN FITZGERALD
ART DIRECTOR	ED SULLIVAN
DESIGNER	FRANCES SCHIFRIN
CLIENT	HBO INDEPENDENT
SOFTWARE	ADOBE ILLUSTRATOR
HARDWARE	MAC, QUANTEL HARRY, PAINTBOX

A Working Landscape

DESIGN FIRM	JANET SCABRINI DESIGN INC.
ART DIRECTOR	JANET SCABRINI
DESIGNER	JANET SCABRINI
CLIENT	SILVESTER TAFURO DESIGN
SOFTWARE	QUANTEL PAINTBOX
HARDWARE	QUANTEL PAINTBOX

Fox Latin America Channel

Design Firm Pittard Sullivan Fitzgerald
Art Director Billy Pittard
Designer Jeff Boortz
Client Fox Inc.
Software Wavefront
Hardware Silicon Graphics, Quantel Harry

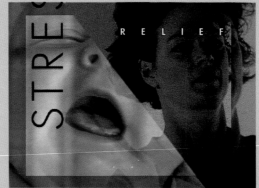
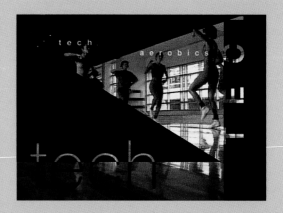
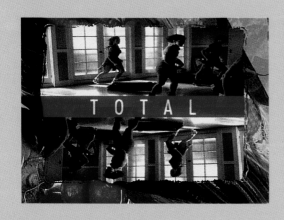
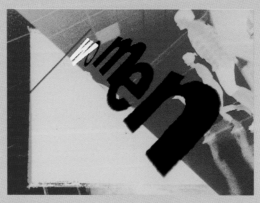

NIKE

DESIGN FIRM PITTARD SULLIVAN FITZGERALD
ART DIRECTOR ED SULLIVAN
DESIGNER LAURA PARESKY
CLIENT ASPECT RATIO
SOFTWARE ADOBE ILLUSTRATOR
HARDWARE MAC, QUANTEL HARRY, HAL, PAINTBOX

DESIGN FIRM VIEWPOINT COMPUTER ANIMATION
CHARACTER DESIGN SCOTT NASH/BIG BLUE DOT
ANIMATION MATT HAUSMAN, BRIAN BRAM
CLIENT REUNION PRODUCTIONS,
 NEW ENGLAND RESEARCH INSTITUTE
SOFTWARE PRISMS
HARDWARE SILICON GRAPHICS WORKSTATIONS

DESIGN FIRM WCV3-TV
ART DIRECTOR MICHAEL TIEDEMANN
DESIGNER MICHAEL TIEDEMANN
CLIENT WCV3-TV
HARDWARE QUANTEL PAINTBOX

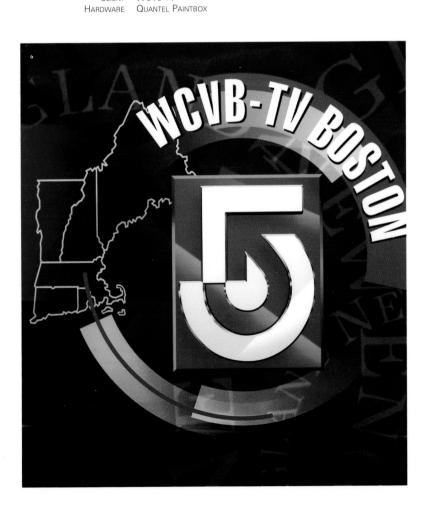

DESIGN FIRM VIEWPOINT COMPUTER ANIMATION
ART DIRECTOR ADRIENNE GOLDMAN
DESIGNER ADRIENNE GOLDMAN
CLIENT LIFETIME TELEVISION
SOFTWARE QUANTEL PAINTBOX
HARDWARE SILICON GRAPHICS WORKSTATIONS

DESIGN FIRM DIRECTORY

ADAM COHEN/ILLUSTRATOR
96 GREENWICH AVENUE
NEW YORK, NY 10011

AMPERSAND DESIGN GROUP
1440 W. 37 STREET
HIALEAH, FL 33012

ANIMUS COMUNICACAO
UADEIRA DO ASCURRA 115-A
22241-320/RIO/RJ/BRAZIL

ART & FUNCTION
JULIO PRADO 1903 NUNOA
SANTIAGO, CHILE

ASIA COMPUTERWORLD
 COMMUNICATION LTD.
701-4 KAM CHUNG BUILDING, 54
JAFFE ROAD
WANCHAI, HONG KONG

ASLAN GRAFIX
6507 RAIN CREEK PARKWAY
AUSTIN, TX 78759

BEELINE GROUP
C/O THARP DID IT
50 UNIVERSITY AVENUE
SUITE 21
LOS GATOS, CA 95030

BETH SANTOS DESIGN
2 VILLAGE HILL LANE
NATICK, MA 01760

BURGEFF COMPANY
TECUALIAPAN 36 VU/8
OYB20 MEXICO, D.F.

COMPUTER ART & DESIGN
140 BERENDOS AVENUE
PACIFICA, CA 94044

CRANBROOK ACADEMY OF ART
1221 NORTH WOODWARD AVENUE
P.O. BOX 801
BLOOMFIELD HILLS, MI 48303

DESIGN ART, INC.
6311 ROMAINE STREET #7311
LOS ANGELES, CA 90038

DUTCHMILL DESIGN
43 DUTCHMILL
WILLIAMSVILLE, NY 14221

EARL GEE DESIGN
501 SECOND STREET
SUITE 700
SAN FRANCISCO, CA 94107

EASTBAY DESIGN STUDIO
529-1/2 NORTH 3RD STREET
APARTMENT #3
WAUSAU, WI 54403

EDUINO J. PEREIRA, GRAPHIC DESIGN
10837-F AMHERST AVENUE
WHEATON, MD 20902

FOCUS 2
3333 ELM STREET
SUITE 203
DALLAS, TX 75226

FRANKFURT BALKIND PARTNERS
244 EAST 58TH STREET
NEW YORK, NY 10022

GABLE DESIGN GROUP
1512 ALASKAN WAY
SEATTLE, WA 98101

THE GRAPHIC EXPRESSION, INC.
330 EAST 59TH STREET
NEW YORK, NY 10022

GROSSMAN ILLUSTRATION
355 W. 51ST STREET #43
NEW YORK, NY 10019

HA! HAYDEN & ASSOCIATES
6112 MISTY PINE COURT
CRYSTAL LAKE, IL 60012

HANDLER GROUP INC.
22 WEST 23RD STREET
NEW YORK, NY 10010

HATFIELD DESIGN
25 ALLEN AVENUE
NEWTON, MA 02168

HORNALL ANDERSON DESIGN WORKS
1008 WESTERN, SUITE 600
SEATTLE, WA 98104

INTEGRATE INC.
503 SOUTH HIGH STREET
COLUMBUS, OH 43215

INTERACT
P.O. BOX 498
ISSAQUAH, WA 98027

JACQUELINE COMSTOCK
2106 HOLLOW ROAD
GLEN SPEY, NY 12737

JACQUELINE SMITH DESIGN
6238 LANGDON
ST. LOUIS, MO 63134

JANET SCABRINI DESIGN INC.
50 WASHINGTON STREET
SOUTH NORWALK, CT 06854

JAVIER ROMERO DESIGN GROUP
24 EAST 23RD STREET #3
NEW YORK, NY 10010

JIM LANGE DESIGN
203 NORTH WABASH AVENUE
CHICAGO, IL 60601

KEN RANEY ILLUSTRATION
433 S. RIDGE ROAD
HESSTON, KS 67062

LARSEN DESIGN OFFICE, INC.
7101 YORK AVENUE SOUTH
SUITE 120
MINNEAPOLIS, MN 55435

LINE DRIVEN COMPUTER
 ILLUSTRATION
579 RICHMOND STREET WEST
SUITE 300
TORONTO, ONTARIO M5V 1YB

M. RENNER DESIGN
WEIHERWEG 3
CH-4123 ALLSCHWIL
SWITZERLAND

MARC ENGLISH: DESIGN
37 WELLINGTON AVENUE
LEXINGTON, MA 02173

MARK K. HAMEL
1703 IRVING STREET #2
RAHWAY, NJ 07065

MAUREEN NAPPI, INC.
229 WEST 78TH STREET #84
NEW YORK, NY 10024

MAX STUDIO
420 NORTH 5TH STREET
SUITE 709
MINNEAPOLIS, MN 55401

THE MIAMI HERALD
1440 W. 37 STREET
HIALEAH, FL 33012

MIKE SALISBURY COMMUNICATIONS
 INC.
2200 AMAPOLA COURT
TORRANCE, CA 90501

NEUMEIER DESIGN TEAM
7 ALMENDRAL AVENUE
ATHERTON, CA 94027

O & J DESIGN
9 WEST 29TH STREET
NEW YORK, NY 10001

P.I. DESIGN CONSULTANTS
1-5 COLVOLLE MEWS
LONSDALE ROAD
LONDON W112AR

PITTARD SULLIVAN FITZGERALD
6430 SUNSET BOULEVARD
SUITE 200
HOLLYWOOD, CA 90028

PLANETARY DISSEMINATION ORG.
6331 HOLLYWOOD BOULEVARD
SUITE 1305
LOS ANGELES, CA 90028

PSEUDAXIS GRAPHICS
1167 TAYLOR STREET
EUGENE, OR 97402

RHODA GROSSMAN GRAPHICS
216 FOURTH STREET
SAULSALITO, CA 94965

RICKABAUGH GRAPHICS
384 W. JOHNSTOWN ROAD
GAHANNA, OH 43230

RILEY DESIGN ASSOCIATES
214 MAIN STREET
SUITE A
SAN MATEO, CA 94401

THE RIORDAN DESIGN GROUP
1001 QUEEN STREET WEST
MISSISSAUGA, ONTARIO
CANADA L5H

SALZMAN DESIGNS
P.O. BOX 158
CADYVILLE, NY 12918

SCHMELTZ + WARREN
74 SHEFFIELD ROAD
COLUMBUS, OH 43214

SEGURA INC.
361 W. CHESTNUT
CHICAGO, IL 60610

SENSE(S)
235 WEST 26TH AVENUE
EUGENE, OR 97405

SHIELDS DESIGN
415 EAST OLIVE AVENUE
FRESNO, CA 93728

STEVE KELLER PRODUCTIONS
80 WEST DAYTON STREET
PASADENA, CA 91105

STUDIO MD
1512 ALASKAN WAY
SEATTLE, WA 98101

STUDIO SEIREENI
708 S. ORANGE GROVE AVENUE
LOS ANGELES, CA 90036

STUDIO TWENTY-SIX MEDIA
209 WEST CENTRAL STREET
SUITE 210
NATICK, MA 01760

T2 PRODUCTIONS
2148 SAND HILL ROAD
MENLO PARK. CA 94025

TRACY SABIN, ILLUSTRATION & DESIGN
13476 RIDLEY ROAD
SAN DIEGO, CA 92129

VAUGHN WEDEEN CREATIVE
407 RIO GRANDE NW
ALBUQUERQUE, NM 87104

VIEWPOINT COMPUTER ANIMATION
13 HIGHLAND CIRCLE
NEEDHAM, MA 02192

WCV3-TV
5 TV PLACE
NEEDHAM, CA 02192

WALCOTT-AYERS GROUP
1230 PRESERVATION PARK
OAKLAND, CA 94612

WATT, ROOP & CO.
1100 SUPERIOR AVENUE
CLEVELAND, OH 44114

THE WELLER INSTITUTE FOR THE CURE
 OF DESIGN INC.
P.O. BOX 726
PARK CITY, UT 84060

WHITNEY EDWARDS DESIGN
3 NORTH HARRISON STREET
P.O. BOX 2425
EASTON, MD 21601

WICKY LEE AD/GRAPHIC DESIGN
7102 WAYNE AVENUE
UPPER DARBY, PA 19082

WOLFRAM RESEARCH, INC.
100 TRADE CENTER DRIVE
CHAMPAIGN, IL 61820

THE WYANT GROUP, INC.
96 EAST AVENUE
NORWALK, CT 06857

MARC YANKUS
570 HUDSON STREET
NEW YORK, NY 10014

DESIGNER DIRECTORY

ANGULO, ANTONIO
KLITSNER I.D.
636 4TH STREET
SAN FRANCISCO, CA 94107

ARONOFF, SUSAN
201 EAST 25TH STREET #11C
NEW YORK, NY 10010

BARTOW, DOUG
1221 N. WOODWARD AVENUE
BLOOMFIELD HILLS, MI 48303

BRICE, JEFF
3131 WESTERN AVENUE #505
SEATTLE, WA 98121

FENSTER, DIANE
140 BERENDOS AVENUE
PACIFICA, CA 94044

GAMBINO, DONALD
12 CAROLYN WAY
PURDYS, NY 10578

GONZALEZ, DAN
1440 W. 37TH STREET
HIALEAH, FL 33012

IIJIMA, CHIKA
SCHOOL OF VISUAL ART
383 1ST AVENUE #7
NEW YORK, NY 10010

JOHNSON, ERIC B.
251 TWINRIDGE DRIVE
SAN LUIS OBISPO, CA 93401

LIPNER, ROBIN
220 WEST 21ST STREET 2E
NEW YORK, NY 10011

MODYELEWSKI, JOHN
THE SCHOOL FOR COMPUTER AUDIO
 VISUAL ARTS
201 ROCK ROAD
SUITE 203
GLEN ROCK, NJ 07452

NESSIM, BARBARA
63 GREENE STREET #503
NEW YORK, NY 10012
NICHOLSON, PHILIP
SEGELVAGEN 36
432 75 TRASLOVSLACE
SWEDEN

PALLOTTA, CHRISTOPHER
311 GREAT ROAD
LITTLETON, MA 01460

POSEY, DAVID
CORPORATE VISIONS
1835 K. STREET NW #500
WASHINGTON, DC 20002

SATLOFF, CYNTHIA
CENTER FOR CREATIVE IMAGING
51 MECHANIC STREET
CAMDEN, ME 04843

SIMPSON KRAUSE, DOROTHY
MASSACHUSETTS COLLEGE OF ART
32 NATHANIEL WAY
BOX 421
MARSHFIELD HILLS, MA 02051

SOWASH, RANDY
550 SUNSET BOULEVARD
MANSFIELD, OH 44907

ILLUSTRATOR DIRECTORY

CHMELEWSKI, KATHLEEN
143 ART & DESIGN
UNIVERSITY OF ILLINOIS
URBANA-CHAMPAIGN
408 EAST PEABODY DRIVE
CHAMPAIGN, IL 61820

CRAMERI, NICOLE
90 LAWTON STREET #2
BROOKLINE, MA 02146

HATHAWAY, ANDREW J.
805 PAGE STREET
SAN FRANCISCO, CA 94117

PATERNOSTER, NANCE
PAINTING SNO PRODUCKSHUNZ
546 WISCONSIN STREET
SAN FRANCISCO, CA 94107

YANKUS, MARC
570 HUDSON STREET
NEW YORK, NY 10014

DESIGN FIRM INDEX

ADAM COHEN/ILLUSTRATOR 78, 79, 81

AMPERSAND DESIGN GROUP 89

ANDROMEDA SOFTWARE 106

ANIMUS COMUNICACAO 22, 43

ART & FUNCTION 34, 133, 139

ASIA COMPUTERWORLD
 COMMUNICATION LTD. 72, 73, 74, 103

ASLAN GRAFIX 13

AXELSSON & CO. 53, 75, 105, 117

BEELINE GROUP 138

BETH SANTOS DESIGN 102

BO LILJEDAL REKLAMBYRA 61

BURGEFF CO. 48, 122

CLARK KELLOG DESIGN 121

COMPUTER ART & DESIGN 126

CRANBROOK ACADEMY OF ART 33

DESIGN ART, INC. 122

DUTCHMILL DESIGN 27, 36

EARL GEE DESIGN 134, 135

EASTBAY DESIGN STUDIO 100

EDUINO J. PEREIRA, GRAPHIC DESIGN 60

FOCUS 2 26, 27

FOOTE, CONE & BELDING 25

FRANKFURT BALKIND PARTNERS 87

GABLE DESIGN GROUP 48

THE GRAPHIC EXPRESSION, INC. 23

GROSSMAN ILLUSTRATION 124

HA! HAYDEN & ASSOCIATES 102

HANDLER GROUP INC. 37

HATFIELD DESIGN 90

HORNALL ANDERSON DESIGN WORKS
 14, 20, 29, 36, 42, 45, 49, 140, 143, 147

INTEGRATE INC. 47

INTERACT 64, 68, 69

JACQUELINE COMSTOCK 59, 115, 146

JACQUELINE SMITH DESIGN 148

JANET SCABRINI DESIGN INC. 41, 145,
 148, 154

JAVIER ROMERO DESIGN GROUP 35, 54,
 71, 148

JIM LANGE DESIGN 24

KAVISH & KAVISH 54, 127

KEN RAMEY ILLUSTRATION 66

LARSEN DESIGN OFFICE, INC. 9, 17, 137

LINE DRIVEN COMPUTER ILLUSTRATION
 131

M. RENNER DESIGN 15, 146, 147, 149

MARC ENGLISH: DESIGN 37

MARK K. HAMEL 85

MAUREEN NAPPI, INC. 82

MAX STUDIO 73

THE MIAMI HERALD 89

MIKE SALISBURY COMMUNICATIONS
 INC. 10, 12, 15, 149

MIRES DESIGN 25, 47

NEUMEIER DESIGN TEAM 141

NICKELODEON ACME CREATIVE GROUP
 100

O & J DESIGN 21

PENWELL GRAPHICS 93

P.I. DESIGN CONSULTANTS 12

PITTARD SULLIVAN FITZGERALD 152, 153,
 154, 155, 156

PLANETARY DISSEMINATION ORG. 140

POPULAR SCIENCE MAGAZINE 120

PSEUDAXIS GRAPHICS 125

RHODA GROSSMAN GRAPHICS 65, 94

RICKABAUGH GRAPHICS 18, 41, 148

RILEY DESIGN ASSOCIATES 138, 142

THE RIORDAN DESIGN GROUP 11

SALZMAN DESIGNS 118

SCHMELTZ AND WARREN 113

SEGURA INC. 12, 21, 136

SENSE(S) 50

SHIELDS DESIGN 22, 31, 40, 101

STEVE KELLER PRODUCTIONS 104

STRADA COMMUNICATIONS LTD. 142

STUDIO MD 48, 57

STUDIO SEIREENI 146

STUDIO TWENTY-SIX MEDIA 92

T2 PRODUCTIONS 84, 116

TIME MAGAZINE 121

TRACY SABIN, ILLUSTRATION & DESIGN
 25, 47

VAUGHN WEDEEN CREATIVE 14, 16, 19,
 42, 140

VIEWPOINT COMPUTER ANIMATION 10,
 151, 157

WCV3-TV 157

WALCOTT-AYERS GROUP 28, 40, 64, 83,
 142

WATT, ROOP & CO. 46

THE WELLER INSTITUTE FOR THE CURE
 FF DESIGN INC. 119

WHITNEY EDWARDS DESIGN 44, 149

WICKY LEE AD/GRAPHIC DESIGN 146

WOLFRAM RESEARCH, INC. 32, 38, 39

THE WYANT GROUP, INC. 51

DESIGNER INDEX

ANGULO, ANTONIO 125

ARONOFF, SUSAN 91

BARTOW, DOUG 30

BRICE, JEFF 43, 59, 96, 97, 98, 99

FENSTER, DIANE 54, 86, 126, 127

GAMBINO, DONALD 80

GONZALEZ, DAN 24, 86

IIJIMA, CHIKA 123

JOHNSON, ERIC B 63

LIPNER, ROBIN 112

MODYELEWSKI, JOHN 56

NESSIM, BARBARA 56

NICHOLSON, PHILIP 53, 55, 61, 67, 75,
 105, 117, 129

PALLOTTA, CHRISTOPHER 62, 88

POSEY, DAVID 58

SATLOFF, CYNTHIA 70, 113

SIMPSON KRAUSE, DOROTHY 108, 109,
 110, 111

SOWASH, RANDY 90

ILLUSTRATOR INDEX

CHMELEWSKI, KATHLEEN 95

CRAMERI, NICOLE 114, 130

HATHAWAY, ANDREW J. 128

PATERNOSTER, NANCE 76, 77

MARC YANKUS 93, 106, 107, 120, 121